IMAGES
of America

DENVER'S CITY PARK AND
WHITTIER NEIGHBORHOODS

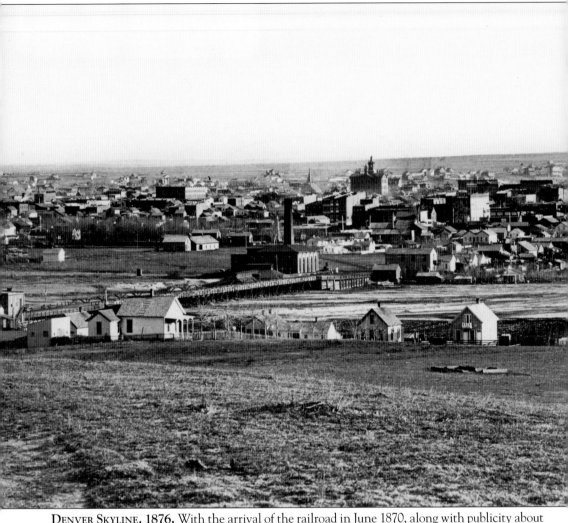

DENVER SKYLINE, 1876. With the arrival of the railroad in June 1870, along with publicity about Colorado's statehood on August 1, 1876, the city of Denver exploded in population. By 1890, the city had more than 100,000 inhabitants. Many of these people were choosing to move away from the crowded downtown areas and into the suburbs. The Whittier neighborhood, shown here as the distant open space on the top left side of the picture, was one of these destinations. This photograph was taken just west of the Platte River near Fifteenth Street. The prominent building (whose bell tower rises above the horizon) was the Arapahoe School. It opened to great fanfare on April 2, 1873, and served all students who wished to attend. (CHS.)

ON THE COVER: Taken in October 1908, this photograph shows the Whittier School football team ready for action. The players' names have been lost to the ages, but their faces tell the whole story. Some are surely children of the builders of Whittier neighborhood. The photograph was most likely taken at nearby Curtis Park with Thirty-second Street in the background. This picture was discovered during a home renovation in Whittier at 1539 East Thirtieth Avenue nearly 100 years after it was taken. (Diedre and Colin Bricker.)

IMAGES
of America

DENVER'S CITY PARK AND WHITTIER NEIGHBORHOODS

Shawn M. Snow

ARCADIA
PUBLISHING

Published by Arcadia Publishing
Charleston SC, Chicago IL, Portsmouth NH, San Francisco CA

Printed in the United States of America

Library of Congress Control Number: 2009928047

For all general information contact Arcadia Publishing at:
Telephone 843-853-2070
Fax 843-853-0044
E-mail sales@arcadiapublishing.com
For customer service and orders:
Toll-Free 1-888-313-2665

Visit us on the Internet at www.arcadiapublishing.com

To Diane, Steve, Gina, and Lori

CONTENTS

ACKNOWLEDGMENTS

This project would not have been possible without enormous help. First I would like to give special thanks to both Aaron Will and Aaron Archer for providing much-needed research assistance. In addition, Aaron Archer gave unselfishly of his time and visited with many people to gather information and scan photographs from people across Denver. And thanks to sisters Cindi Wallace and Sandi Robben for sharing their amazing family chronicle of history in the neighborhood. Special thanks also to photographer Minka Frohring for giving advice on scanners and photographs and for also taking numerous pictures for this volume.

Thanks also to the following people, in no particular order, for providing help, advice, assistance, pictures, or all of the above: Nisa'a Amin, Ray Acsell, Gail Dow, Diedre Bricker, Joyce Dillon, Marge Hook, Mel G. Garcia, Margaret S. Garcia, Kate Johnson, Heidi Kennedy, Sean Campbell, Victoria Kirby, Gary Kleiner, Linda Dowlen, La Wanna Larson, Joe Martell, Jim McNally, Tom Noel, Lynette Prosser, Nicki Rounds, John Ford, Bud Scott, Sherry Dennis, Amy Zimmer, Kenton Forrest, Rene Payne, Lisa Crunk, Patti Blazon, Duncan McCollum, Coi Drummond-Gehrig, Bruce Hanson, Wendell Cox, Jenny Vega, Linda Lebsack, Anne Bond, Don and Carolyn Etter, Laura Mauck, John Olson, Ginger Reichert, Judi Wright, Pernell Steen, Kathy Davis, Kathy Hill, Tom Simmons, Kristine Eklund Butler, Cathy Calder, Hannah Carney, and Jerry Roberts. And, of course, thanks to Kevin Pharris, also known as "scanner monkey."

Many pictures in this volume can be attributed to the following: the Galilee Baptist Church (GBC); the Kate Johnson Collection (KJC); the Buffalo Bill Historical Center (BBHC); the Gary Kleiner Collection (GKC); Manual High School (MHS); the Whittier Elementary School (WES); the Van Loon daughters, Cindi Wallace and Sandi Robben (VLD); the *Denver Municipal Facts* (DMF); the Colorado Railroad Museum (CRRM); the Kenton Forrest Collection (KFC); the Denver Museum of Nature and Science (DMNS); the Denver Public Library Western History Collection (DPL WHC); and the Colorado Historical Society (CHS).

INTRODUCTION

The glitter of gold in Denver was brilliant but fleeting, illuminating faces and fortunes, sometimes for only a second. It made a choice few very rich. While such stories capture the imagination, the bulk of lives lived in Denver will never be recorded for posterity. Denver was born in 1858—a start-up town cobbled together over the promise of gold found near the confluence of Cherry Creek and the South Platte River. With a railroad connection arriving in 1870, real estate took off, and the Denver known today began to prosper. But what of the tales of these everyday people who made up this new city? Where did they live, and what were their stories? Certainly every story cannot be told. In that sense, it is the luck of the draw. What pictures can be found for a neighborhood such as Whittier, promoted as early as 1868?

Famous residents such as U.S. senator Charles Hughes of 2036 Emerson Street; suffragette and Colorado State University professor Theodosia Ammons, who resided at 2345 Franklin Street; and David Dryden, a designer of numerous Denver schools, who lived at 2557 Gilpin Street are easier to research. Their homes remain standing, and the neighborhood as a whole has survived as a testament to those who came before. Whittier was situated far enough from downtown to escape the full-scale plundering of the built environment that occurred after the introduction of the automobile, when much of the land was cleared there for parking lots. But Whittier was also saved for another reason: growing racial segregation, which in a sense, preserved housing because people had few options for moving elsewhere.

Prior to the 1920s, the Whittier neighborhood was essentially a white, middle-class area. Black citizens began to concentrate more in the Five Points area just west of Whittier around 1895. With growing numbers, the pressures to find new housing opportunities increased. This demographic shift was not noticed greatly until the 1920s, when large numbers of blacks began arriving in Denver as part of the Great Migration of 1916–1919. The change was so dramatic that it created Denver's first majority black school. Prior to this time, black students attended many Denver schools in smaller numbers. But as teacher Gladys Maclin noted in March 1931, "The story of Whittier School is one of changing population. Ten years ago the colored child was in the minority; today, eighty percent of the pupils of this school are Negroes."

Indeed, such changes mirrored shifts all across northeast Denver. Growing African American populations demanded fair accommodation in housing. White citizens many times formed neighborhood improvement associations to keep blacks and other minorities out due to fears of a neighborhood being "taken over." Eventually, however, a shift was inevitable, and whites moved out. As Laurie and Thomas Simmons noted, "The construction of the new Manual . . . necessitated the removal of fifty to sixty houses, mostly occupied by African-American families. Realtors, [sought] replacement housing . . . in eastern Whittier. . . . The result was 'the moving of seventy-five percent of the white home owners and the conversion of the area into a predominately Negro neighborhood.' "

While these racial shifts were changing Whittier, the overall population was declining as well, affected by the same desire of most people to live in newer suburban housing. In 1950, the population of Whittier was 9,160, with about 40 percent of that total being white. By 1990, the population was just 4,332, with a 12-percent white population. About 25 percent of housing stood vacant in Whittier by 1990 as well. Changes in fair housing laws, as well as an explosion in new construction following 1945, resulted in an exodus of many people from older sections of Denver. Still the percentage of African Americans in Whittier stood at 75 percent in 1990, even though the overall population had fallen to half of what it had been in 1950. The vibrant black community that had been created in Five Points and in the Whittier area because of segregation was less apparent by 1990 as blacks enjoyed options for moving to other areas of the city without persecution. Such a reality left Whittier's housing stock in desperate need of attention. Cheap prices on these homes and a reversal in negative feelings toward city living, along with an evolution in attitudes by white and Hispanic homeowners and renters, allowed for Whittier's population to grow and diversify after 1990. By 2005, the population was estimated to be 5,396, with the 2000 census showing the area to be about 20 percent white, 44 percent black, and 32 percent Hispanic. Trends since 2000 indicate even more equalization in racial percentages. Whittier today is one of the most diverse areas in all of Denver. And while many homes were demolished following 1945, roughly 75 percent of the remaining housing in Whittier was built prior to 1940.

Although suffering from the same type of neglect after 1945 that afflicted much of old Denver, City Park has persevered to the present day largely intact and with many beautiful trees. The Denver Museum of Nature and Science, along with the Denver Zoo, are among the most visited attractions in the entire state. The Whittier Oak Tree is gone, planted sometime in the 1880s along York Street, and many elms that were planted in 1910 are gone because of disease. But other improvements, funded by some of the $500,000 investment made by private Denver citizens a century ago, are still apparent in City Park. In addition, large reinvestments in park infrastructure have occurred since 1990. All together, Denver's City Park and Whittier neighborhoods have enjoyed new appreciation at the dawn of the 21st century, as all citizens work to build upon past successes and continue creating a community built on mutual respect for the common good.

FROM THE AUTHOR
The stories of the Whittier and City Park neighborhoods are many and varied. All of us have stories to tell, but the trick is finding those stories and, in the case of this book, relating them to available photographic evidence. It has been my endeavor to leave no stone unturned during the past year in my quest to find pictures and interesting stories to go with them. This has been no easy task, especially in locating pictures from the earliest days of the neighborhood. In addition, early photographs from African American experiences in Whittier and City Park are surprisingly rare. Readers should be aware of two Arcadia Publishing volumes that do a great job in documenting related black history in Colorado, as well as in the Five Points area, which lies to the west of Whittier. Consult Images of America: *African Americans of Denver* as well as Images of America: *Five Points Neighborhood of Denver* for more information. Otherwise, I did my absolute best to find enough pictures to give a taste of Whittier and City Park history from 1880 to 1950. Everyone has a story to tell, and anyone's story can end up being history if presented to a wider audience.

One

SUBURBAN BLISS

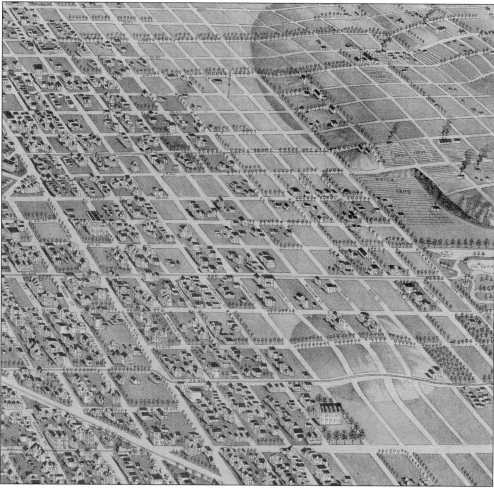

THE WHITTIER AREA PERSPECTIVE MAP, 1889. Whittier was a new residential area in the 1880s. This neighborhood, bounded by Twenty-third Avenue on the south, Thirty-second Avenue on the north, Downing Street on the west, and York Street on the east, eventually took its name from the school of the same name at Twenty-fourth Avenue and Marion Street. City Park was platted just to the south of Twenty-third Avenue and east of York Street in 1882. By the beginning of the 20th century, the park was a huge tourist attraction. (DPL WHC, 4314.)

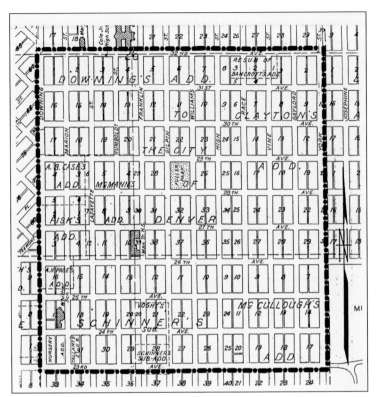

WHITTIER SUBDIVISION PLAT, 1945. This map shows the names of some of Denver's earliest residents. They were able to take full advantage of the city's growth. These subdivisions included developments by Alfred Case (1868); Jacob Downing (1869); Adolph Schinner (1870); George McCullough (1872); and William and George Clayton (1889), along with smaller additions made by Archie Fisk (1874) and Robert McMann (1887). (DPL WHC.)

ROCKY MOUNTAIN NEWS, JULY 7, 1880. Whittier's housing construction blossomed throughout the 1880s and up until 1893, when an economic depression took hold of Denver. This advertisement shows that lots in Fisk's Addition were going for $225 each, while Downing's Addition offered a bargain on lots for $100 a piece. Suburban Capitol Hill lots on Sherman and Grant Streets were much more expensive, while downtown lots on Fifteenth Street and Tremont Place went for more than $2,700. (DPL WHC.)

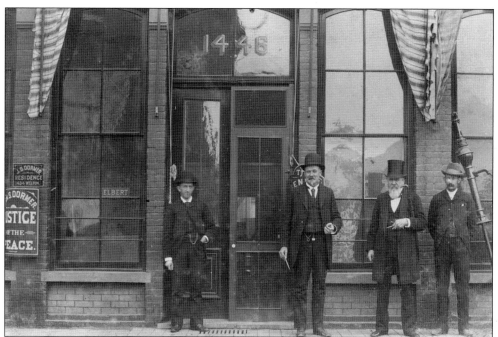

THE LARGEST SUBDIVISIONS. Jacob Downing (above, second from left) is standing next to former territorial governor John Evans (in a top hat). Downing commanded troops in the Civil War and was also involved in the notorious Sand Creek Massacre in 1864. Both he and Evans were huge promoters of the city. Downing's ideas included obtaining parkland in both east and west Denver to be joined by a parkway. His modified vision contributed to the eventual establishment of City Park. Adolph Schinner (at right) had established Denver's first bakery before setting his sights on real estate. His addition stretched from Twentieth to Twenty-sixth Avenues. Schinner named a street after one of the most famous scientists of the 19th century, Alexander von Humboldt. The former Park Street eventually became known as Marion Street, named after Schinner's friend Josie Marion. (Above, DPL WHC; at right, CHS, No. 10039329.)

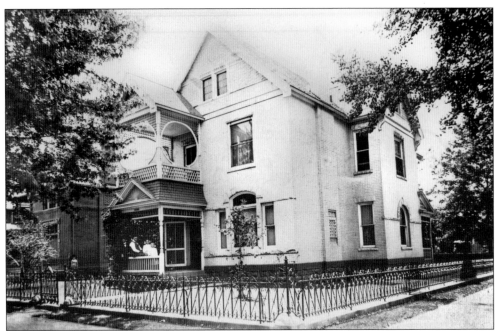

THE LINDQUIST HOME AND FACTORY. The Whittier neighborhood attracted a variety of citizens to brand-new homes being built on the once-empty prairie. The Carl M. Lindquist family took up residence at 2759 Humboldt Street in a large Victorian home. For a time, Lindquist ran the Lindquist Cracker Company at 3512 Walnut Street, which was in business from 1891 to 1929. He joined the ranks of other middle-class Denverites who were leaving the crowded conditions of downtown for greener pastures in the new suburbs. Lawyers, doctors, teachers, shopkeepers, carpenters, and other similar professions were the typical residents during these early years. Architectural styles included Dutch Colonial, Queen Anne, classic cottage, terraces, Italianate, and later the foursquare. While many of Whittier's architectural gems remain intact, the Lindquist home is not among the survivors. (Above, CHS, No. 10039330; below No. 10039331.)

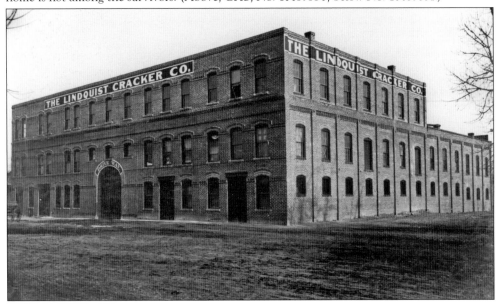

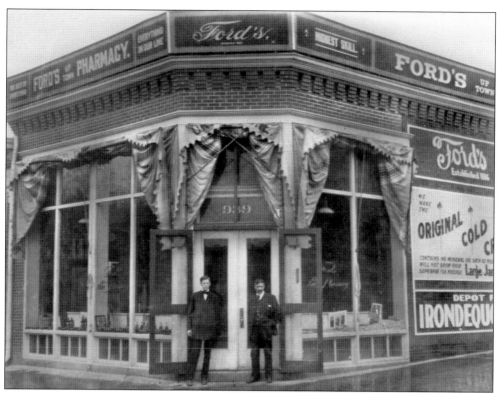

FORD'S, ESTABLISHED 1896. Charles R. Ford (right) operated drugstores, including a downtown location and the one shown here at 939 Eleventh Avenue in Capitol Hill. His son, Charles S. Ford, stands next to him in 1910, with signage touting "Ford's Uptown Pharmacy." This building still stands at Eleventh Avenue and Ogden Street, as does Ford's home, located two blocks west of Whittier at 2351 Emerson Street. (CHS, No. 10039332.)

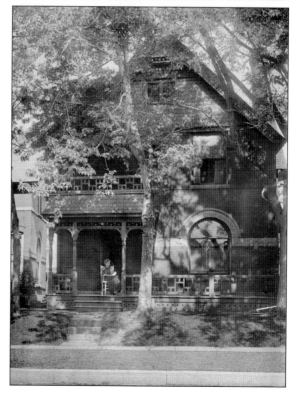

BUFFALO BILL WAS HERE. The home of May Cody Decker, the sister of William F. "Buffalo Bill" Cody, remains standing at 2932 Lafayette Street. This c. 1920 picture shows Decker sitting on her front porch. The home, built in 1892, also has the distinction of being the place where Buffalo Bill died in 1917. The City of Denver had him buried on Lookout Mountain overlooking the city and plains far below. (BBHC, Cody, WY; P.69.1856.)

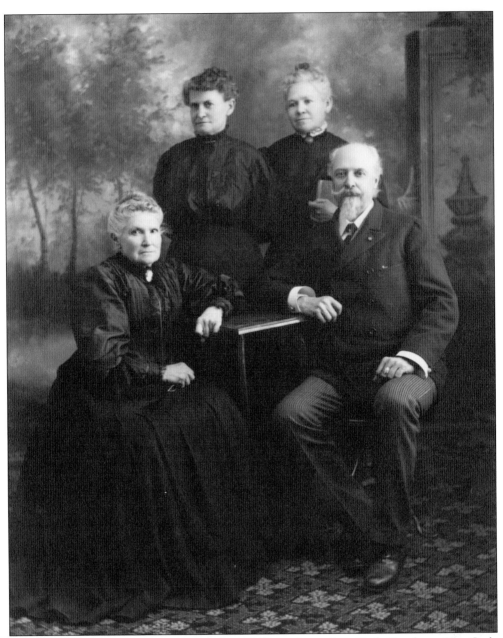

BUFFALO BILL AND HIS SISTERS, C. 1907. From left to right are Julia Cody Goodman, May Cody Decker, Helen Cody Wetmore, and Buffalo Bill Cody. He was world famous and often traveled with his Wild West shows, performing with other Western figures starting in 1872. During the early years, Buffalo Bill often had family members portrayed, including May Cody, in the unfolding drama. In one particular story called "May Cody, or Lost and Won," May is kidnapped and must be rescued. Buffalo Bill later performed with Sitting Bull, Annie Oakley, and others. He was at the Chicago World's Fair in 1893 and performed extensively in Europe. His legacy included fighting for the rights of the bison he had once slaughtered to feed railroad workers, as well as speaking out against injustices toward Native Americans. (BBHC, Cody, WY; Original Buffalo Bill Museum Collection, P.69.975.)

Two

THE TICKET HOME

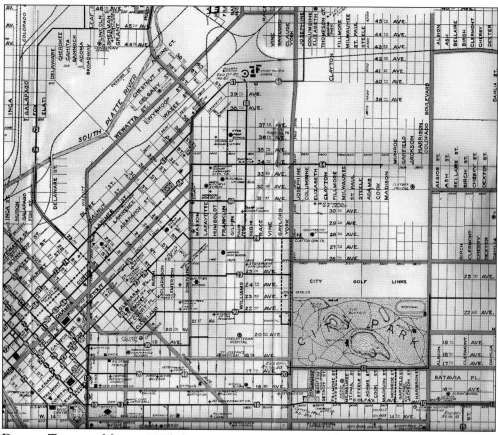

DENVER TRAMWAY MAP, c. 1925. An extensive streetcar network grew quickly to serve Denver's burgeoning population. So-called streetcar suburbs such as Curtis Park, Whittier, Harman, Barnum, and numerous other areas connected to downtown Denver via public transit. Most routes eventually tied into downtown's Central Loop at Fifteenth and Arapahoe Streets. The map shows numbered tramway routes with bold lines. (Author's collection.)

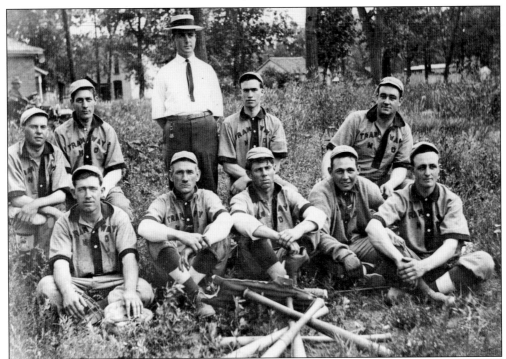

DENVER TRAMWAY BASEBALL TEAM, NORTH DIVISION. The man standing in the background is Earl Payne, a dispatcher at the Central Loop. Whittier and other east Denver neighborhoods were part of the East Division and would have had a similar baseball team. All divisions would have taken part in such recreation. This picture was taken around 1915. (CHS, No. 10039333.)

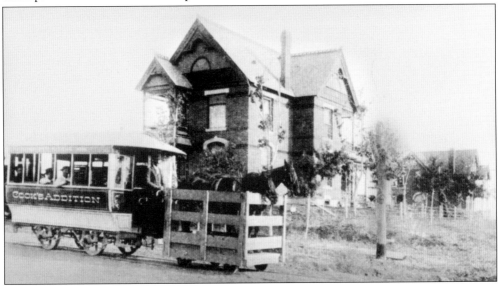

HORSECAR TO COOK'S ADDITION, C. 1885. Horsecar lines began service as early as 1871. Cable cars were in use on certain routes in 1888. But it was the electric streetcar that had the biggest impact. While wagons and carriages were ubiquitous sights, faster service via public transit was a big real estate draw. John Cook Jr. platted his subdivision north of City Park at Thirty-fourth Avenue and Cook Street, calling it the North Division of Capitol Hill. Locals called it Cook's Hill. (CRRM.)

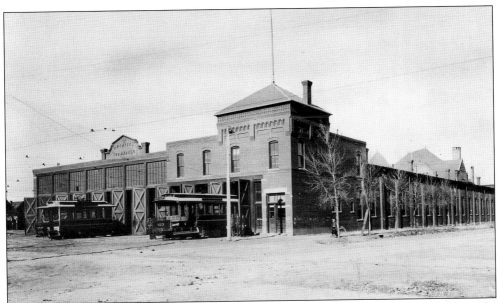

EAST DIVISION CAR BARN, THIRTY-FIFTH AVENUE AND GILPIN STREET, FEBRUARY 1899. The Denver Tramway Company had intense competition with the Denver City Cable Railway Company. By 1899, however, the Denver Tramway Company was the only game in town. This picture also shows the roof of Hyde Park Elementary School in the distance. (Photograph by James Kunkle, Tom Noel Collection.)

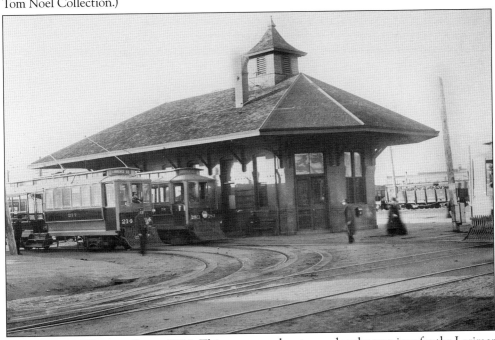

FORTIETH AND WILLIAMS LOOP, 1906. This passenger depot served as the terminus for the Larimer route downtown and also connected passengers to Swansea and Elyria. During 1900, the system carried more than 35 million passengers, all for 5¢ per ride. An elaborate transit organization developed wherein a citizen of Whittier could ride downtown and then connect to outlying areas such as Golden, Arvada, and Boulder. (CRRM.)

17

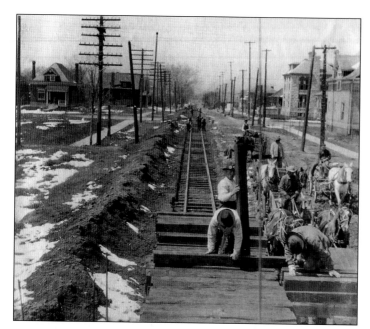

TWENTY-FIFTH AVENUE AND RACE STREET, APRIL 22, 1907. Workers are seen unloading ties for improvements to the East Twenty-fifth Avenue streetcar line. In the upper right corner of the photograph can be seen the Miller House at 2501 High Street. Designed in 1902 by Robert Russell, who used rusticated stone in the design, this unique structure (that still stands) was the home of banker Byron Miller until 1948. (Photograph by Gilbert L. Davis, CRRM.)

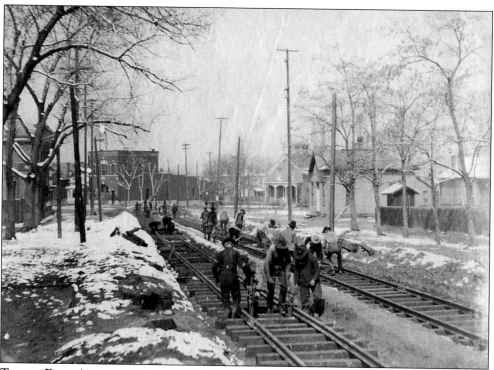

TWENTY-FIFTH AVENUE AND CLARKSON STREET, MAY 3, 1907. The East Twenty-fifth Avenue line connected to downtown via nearby Welton Street. This intersection, near the official Five Points juncture of streets, actually joins together Washington Street, Twenty-fifth Avenue, Twenty-sixth Street, and Glenarm Place. The building in the distance is Fire Station No. 3, organized in 1882. After 1892, the station began hiring members of the growing black community into the ranks of Denver firefighters. (Photograph by Gilbert L. Davis, CRRM.)

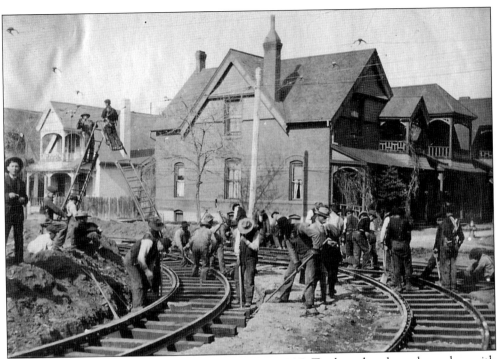

THIRTY-FIRST AVENUE AND HIGH STREET, MAY 16, 1907. Track workers busy themselves with making adjustments to tramway tracks. The house in the center of the picture still stands at this intersection in a somewhat modified condition. Under the leadership of William Gray Evans after 1901, the Denver Tramway Company continued to expand its operations by acquiring outlying lines by 1914, reaching its maximum size that year. (Photograph by Gilbert L. Davis, CRRM.)

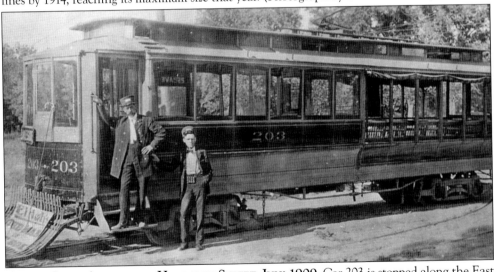

TWENTY-SIXTH AVENUE AND HUMBOLDT STREET, JULY 1909. Car 203 is stopped along the East Twenty-fifth Avenue line near one of Whittier's retail districts. At one time, residents could walk to the Busy Corner Lunchroom at 2600 Humboldt Street or its neighbor, Clark's Barber Shop. The Lafayette Market could be found at 2601 Lafayette Street. While some remnant neighborhood retail remains in the Whittier area, most businesses along Twenty-sixth Avenue have been erased from history. (Photograph by Archie Campbell, CRRM.)

SOLDIERS ON DUTY, AUGUST 1920. Federal troops are shown patrolling the East Division Car Barn. After World War I, a contentious and harmful strike shattered the Denver Tramway Company's facilities and operations. When the company tried to cut wages back to previous levels, angry workers responded by killing at least seven men, burning trains, storming car barns, throwing bricks, using guns, and creating general destruction. (CRRM.)

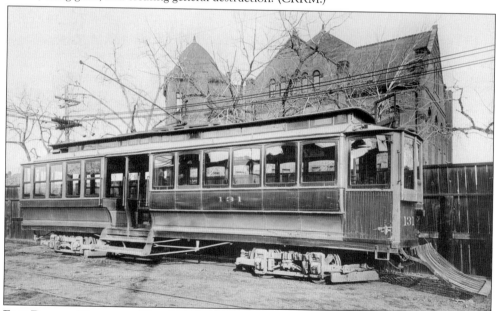

EAST DIVISION TRAM WITH HYDE PARK SCHOOL, 1924. Striking tramway workers were one problem for the company, but the introduction of the automobile was really the nail in the coffin for this form of public transportation. A long, slow demise of streetcars began with the introduction of buses on some routes. The East Division Car Barn closed down in 1932 but reemerged in 1937 as the Motor Coach Division. (CRRM.)

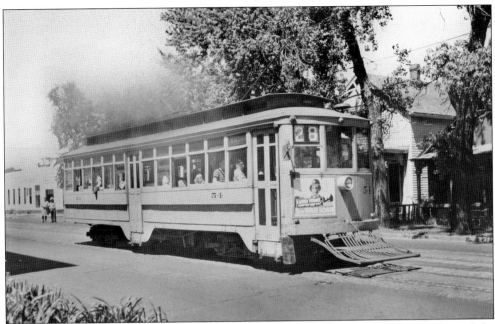

EAST TWENTY-EIGHTH AVENUE LINE, JUNE 10, 1944. The convenience and ease of use of the system became apparent once more during World War II. The trams enjoyed some of their greatest use during these years. One of the larger streetcar networks in the nation, the Denver Tramway Company had affected the city's growth patterns for more than 50 years. The advertisement on Car 54 reads in part, "I died today, what did you do?" (Photograph by W. C. Whittaker, CRRM.)

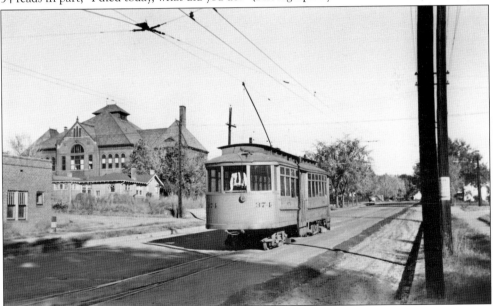

TWENTY-EIGHTH AVENUE AND JOSEPHINE STREET, C. 1945. Car 374 is being backed up at the end of its route. In the background is the Columbine Elementary School, built in 1893 and located just north of City Park. The school took its name from the street where it was located. In 1891, Colorado schoolchildren had voted the lavender and white columbine as their top choice for the state flower. The legislature made it official in 1899. (CRRM.)

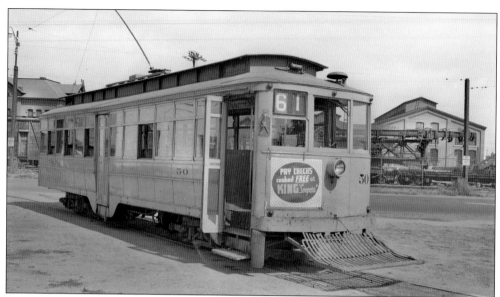

FORTIETH AVENUE AND HIGH STREET, AUGUST 27, 1949. Route 61, the Larimer line, is shown here with the Union Pacific shops in the background. For Denverites, a familiar grocery store name graces the sign on the tram, wherein the advertisement states, "Pay Checks Cashed Free at King Soopers." (Photograph by P. B. Dunn, CRRM.)

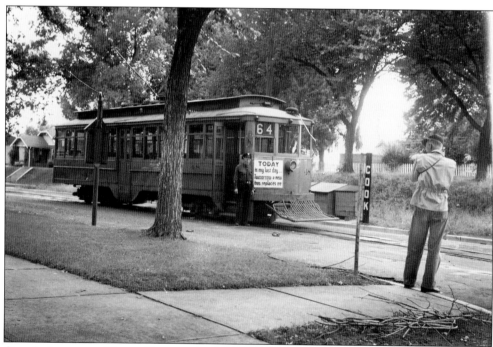

COOK'S ADDITION, THIRTY-FOURTH AVENUE AND COOK STREET, SEPTEMBER 1949. Nostalgia reigned during 1949 and 1950 as the Denver Tramway Company replaced the rest of its streetcars with buses. This huge disinvestment in the central portions of Denver also indicated that the automobile was taking many residents away as they moved to newer suburbs at the edge of the old city. The car would now dictate growth patterns. (Photograph by D. Clint Jr., CRRM.)

Three

THERE WERE THREE Rs
IN WHITTIER

LETTER FROM JOHN GREENLEAF WHITTIER, 1883. The Whittier neighborhood takes its name from the school, which in turn was named for the poet and abolitionist. During the early 1880s, the Denver school district began naming schools after people, including literary figures Henry Wadsworth Longfellow and Ralph Waldo Emerson. Wrote Whittier, "I shall esteem it a very high compliment if the new and spacious school house in Denver is to bear my name." (WES.)

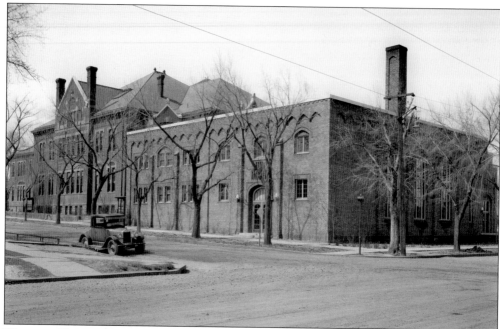

WHITTIER ELEMENTARY SCHOOL, C. 1920. Architect Robert Roeschlaub designed the Whittier School and numerous other school buildings for Denver starting in 1873. The Whittier building opened with 12 rooms in the fall of 1883 on Park Street (present-day Marion Street). With additions coming in 1888 and 1894 to serve the growing suburban population, the Whittier School became the largest elementary school in Colorado. This photograph shows a surviving 1931 addition on the far right. (DPL WHC, MCC-3723.)

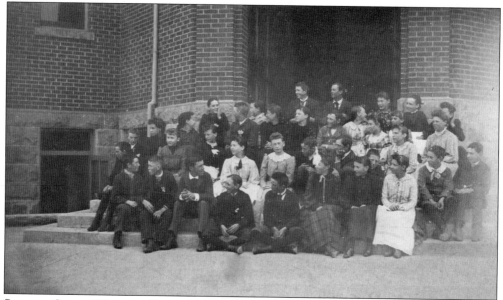

SEVENTH GRADE, WHITTIER SCHOOL, JUNE 1891. For school portraits, this one is a rarity, showing the students in an informal setting. One can almost hear their laughter after peering at the picture! It was found in an old trunk in Michigan in 1993. Returned to the school, the attached letter stated that it was possible that a member of the Purchase family was in the photograph. (WES.)

HERBERT MUNROE, WHITTIER LYCEUM, 1887. Living for a time at 2259 Franklin Street, Herbert Munroe attended the Whittier School from the day it opened in 1883. Graduating from East High School in 1891, Munroe was working as an attorney for the Denver Public Schools by 1897. He was instrumental in pushing for the new East High School to be built next to City Park. A school was named in his honor in southwest Denver in 1962. (WES.)

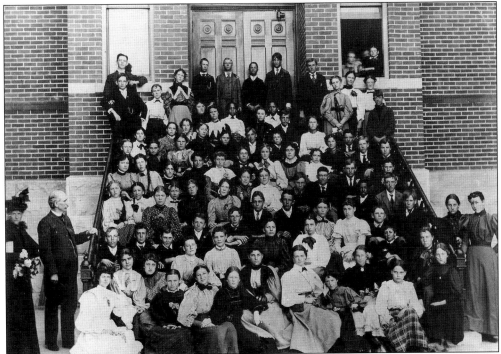

NINTH-GRADE GRADUATION, WHITTIER SCHOOL, JUNE 7, 1897. Most students during this era never completed school past the eighth grade. This class of graduates therefore was headed to Manual High School, or perhaps East High School, with all the hopes and optimism of the coming century in their expressions. Perhaps the principal is standing at the left side of the portrait, or could it be proud parents? (WES.)

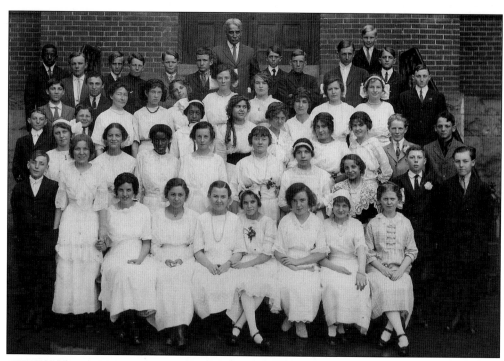

PUPILS' NAMES Arrange alphabetically, last names first BOYS	Check Enrollment			Date of Birth	Age Sept. 1st	Country of Birth	Vaccination Check	Names and addresses of parents	
	Original	Trans-fers							
	a	b	c	d					
1 Benson, Forest			✓			10	U.S.		Fred Benson 1862 Lafayette
2 Bernstein, Leonard						9	U.S.		Sam Bernstein 311 E 22 Ave
3 Blackshear, Harold						9	U.S.		William Blackshear Lafayette
4 Burkett, Clarence			✓			9	U.S.		Clarence Burkett 2608 Ogden
5 Cook, Rodney						9½	U.S.		C. J. Starbuck (foster) 2706 Ogden
6 Center, Gilbert			✓			9½	U.S.		Irving Center 2330 Washington
7 Fishelson, Nelson	✓					9½	U.S.		Sam Fishelson 1128 Lafayette
8 Griffith, Stanley			✓			10	U.S.		Mary E. Griffith 212 E 24 Ave
9 O'Gram, Robert						9½	U.S.		Robert O'Gram 1922 Humboldt
10 Pendley, Julian						9½	U.S.		Lilian Pendley 2612 Williams
11 Sanchez, Walter			✓			9½	U.S.		Raymond Sanchez Lafayette
12 Schlotterer, Walter			✓			9	U.S.		Mrs. E. W. Hammerton Olive
13 Schnebeck, Paul			✓			8½	U.S.		F. A. Schnebeck E 22 Ave
14 Seaman, Harold						9½	U.S.		Harry Seaman 1121 Washington
15 Williams, Harvey						11	U.S.		U. S. Williams Lafayette
16 Caldwell, Langston	✓						U.S.		Wilbur Caldwell 2038 Lafayette
17 Lawson, James	✓					10	U.S.		James L. Lawson 2641 Franklin
18 Gitman, Herman						9	U.S.		Joseph Gitman 2621 Lafayette
19 Williams, Cecil	✓					12	U.S.		Roger Davis 2329 Lafayette
20									

** Indicate in the proper column the number of days pupils enrolled from other schools have been members in the grades.
a. Include pupils from the public schools in the city.
b. Include pupils from private and parochial schools in the city.
c. Include pupils from schools outside the city.
d. Include pupils transferred from other buildings in the city.
e. Include pupils transferred from other rooms in the building.

WHITTIER CLASSMATES, JUNE 1914. This photograph made its way back to the Whittier School in 1990. Ruth Cowdery Cohig is identified as being in the third row, third girl from the right, in the striped dress. White dresses have replaced the more colorful 19th-century fashion for the girls. (WES.)

CLASS 4A, VIOLET G. WALTER, SPRING OF 1926. The perfect penmanship shows mastery of the Zaner-Bloser method of cursive handwriting. Used by generations of school children after its introduction in 1904, it can be assumed that this teacher stressed the importance of penmanship to her students. This roll book shows one snapshot in time of student names, their birth dates, the name of a parent, and their home addresses in the Whittier area. (WES.)

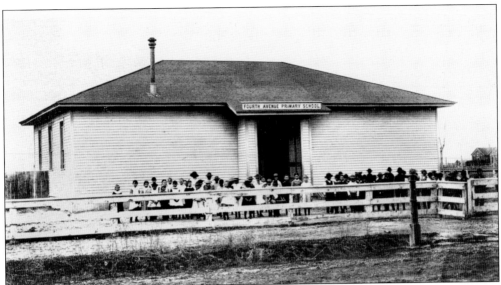

FOURTH AVENUE PRIMARY SCHOOL, C. 1880. As Denver expanded, a growing confusion emerged as each developer decided upon the names of streets. The city began to mandate changes to the whole system in earnest between 1886 and 1904 to bring about more uniformity. This school became known as the Thirty-second Avenue Primary and, later, the Lafayette School. A grander, permanent building was opened as the Maria Mitchell School in 1899. (KFC.)

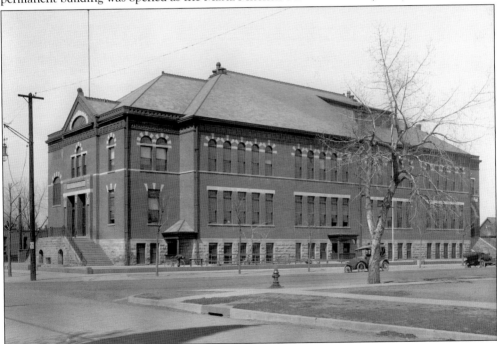

MARIA MITCHELL ELEMENTARY SCHOOL, C. 1920. This was the second school in Denver to be named after a woman, with the first being named for Louisa May Alcott in 1892. Maria Mitchell caught the nation's attention due to her work as an astronomer. She was the first faculty member of Vassar College as well. This neighborhood school building did not survive the 20th century, and its replacement facility was closed in 2008. (DPL WHC, MCC-3778.)

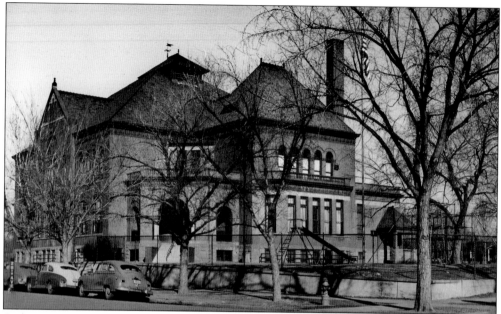

COLUMBINE ELEMENTARY SCHOOL, C. 1945. Columbine was designed by Robert Roeschlaub during a flurry of school construction. Between 1873 and 1893, fifty-seven schools were constructed in Denver's school districts. After World War II, however, these landmark buildings, such as Columbine, were seen as dinosaurs from another era. They were too expensive to update and too unappreciated to save. The last of the old Columbine was demolished in 1977. (Columbine School.)

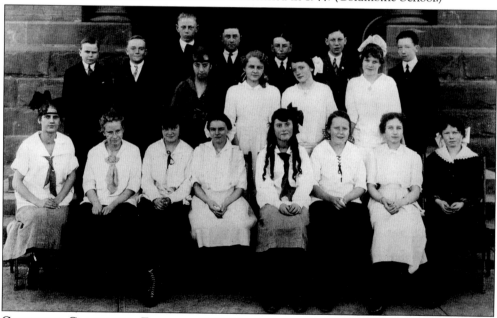

COLUMBINE CLASSMATES, FEBRUARY 1917. Numerous generations of families have attended Columbine, including former Denver mayor Tom Currigan. The streetcar's early presence by the 1880s spurred growth in this area as well. Strangely, the photographic history of this school is rare. This picture was found behind a wall of a neighborhood house undergoing renovation. It was donated to the school. (Columbine School.)

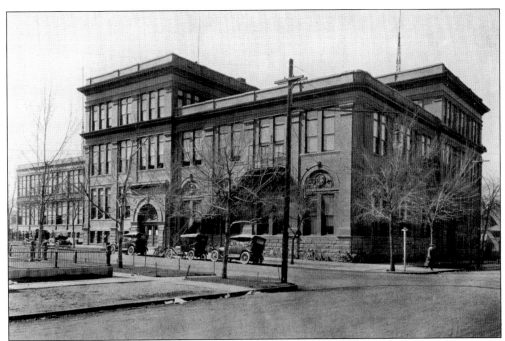

MANUAL TRAINING HIGH SCHOOL, 1919. Manual has been a neighborhood institution since 1894. Designed by Robert Roeschlaub, it opened to complement nearby East High School, which was then located downtown at Nineteenth and Stout Streets. Contrary to popular belief, Manual opened as a school offering traditional academic subjects to prepare students for college, as well as devoting one third of their time to shop work and other trades. (MHS.)

CELESTINE ALICE JONES, CLASS OF 1897. Both male and female students were admitted to Manual Training High School (MTHS) from day one. In addition, Denver's schools had been physically integrated since 1873. Manual's focus on developing cooperative thinking is expressed in this early quote from a syllabus, "To bring thought and labor together; to make the thinker a worker and the worker a thinker." Celestine Jones's thoughts on all of this have been lost to history. (MHS.)

GRACE ROESCHLAUB, CLASS OF 1897. Although living at 1461 Delaware Street and being much closer to East High School, Grace Roeschlaub decided to ride the streetcar to a brand new Manual Training High School, which had been designed by her architect father. Boys focused their manual training on forge and machine, while the girls were trained in cooking, sewing, and millinery. All students took woodworking, drawing, chorus, and calisthenics. (MHS.)

VIOLET TOOVEY, CLASS OF 1899. It is difficult to imagine Violet Toovey removing her hat and furs long enough to take part in any manual training. Such skills, taught in the forum of public education, were then seen as cutting edge. According to Carrie Orton, over the auditorium windows were decorations reflecting this idea, "Sculptured saws, hammers, axes, squares and compasses, drawing instruments, retorts, and test-tubes." (MHS.)

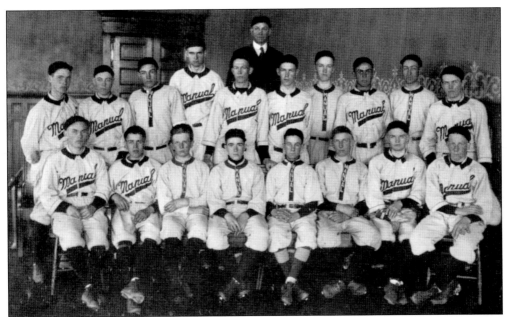

MTHS Boys Baseball Team, 1919. Despite having no gymnasium in the school until 1924, sports were big events at Manual Training High School for both girls and boys. Nearby Fuller Park could be used for sports, along with a small lot behind the school. Manual proudly displayed its red and blue school colors, as well as embracing its dual nicknames, the Manual Bricklayers and the Manual Thunderbolts. (MHS.)

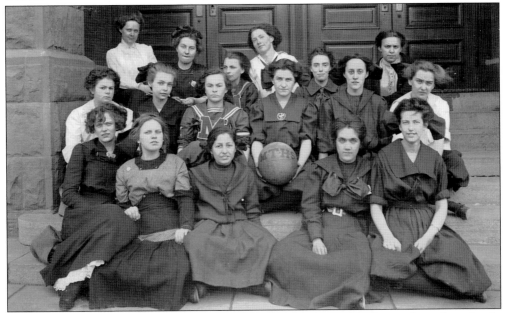

MTHS Girls Basketball Team, c. 1905. This girls' sports team was a force to be reckoned with. Winning championships resulted in continuing dedication and belief in girls being allowed to participate in such activities. While involvement in sports became less common after the 1920s, the early 20th century was a golden age for girls as less restrictive clothing became the norm, allowing for more participation. (DPL WHC, X-28485.)

HAND-CARVED SEAT BY MR. HENDERSON'S PUPILS, C. 1927. As difficult as it is to believe, this stunning creation was made by students. Early histories of Manual Training High School state the following, "The articles made in the shops are not offered for sale, and indeed seldom have any intrinsic value, save as illustrations of certain forms and principles." This chair would certainly demand a high price today, but its location is unknown. It once graced principal Charles Bradley's office. (Author's collection.)

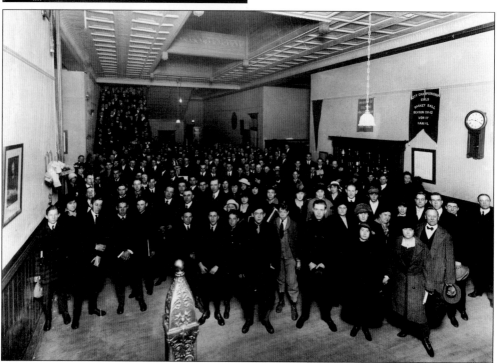

MANUAL EVENING HIGH SCHOOL STUDENTS, C. 1915. So popular were courses in the manual trades that the Denver Public Schools began offering evening courses for all ages. Eventually the old Longfellow School downtown at Thirteenth and Welton Streets was converted into additional space for Manual students. By 1916, the Emily Griffith Opportunity School had taken over the space, proclaiming its use "for all who wish to learn." (KFC.)

MANUAL EVENING HIGH SCHOOL SCULPTURE CLASS. This mixed class of students showed the interest from both sexes in sculpture. A couple of prominent busts show the popular Abraham Lincoln in progress. Most interesting however is the boy posing for his bust, being sculpted perhaps by his mother. (KFC.)

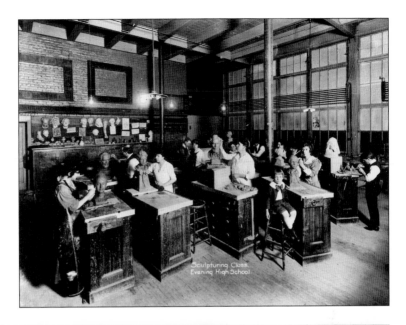

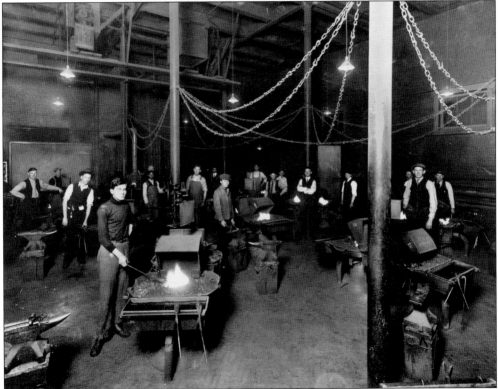

MANUAL EVENING HIGH SCHOOL METAL CLASS. The notion of teaching manual trades in any school was not without controversy when Chester Morey and former governor James Grant suggested it in 1892 to a skeptical Denver School Board. Shouldn't cooking be taught at home? But the popularity and utility of such coursework is still here today with schools offering subjects such as home economics, wood shop, art, drafting, and other industrial arts education. (KFC.)

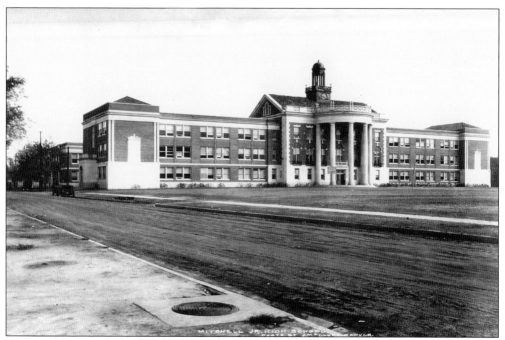

CARLOS M. COLE JUNIOR HIGH SCHOOL, 1925. Located at Thirty-second Avenue and Humboldt Street, this Georgian-style gem was designed by architect William N. Bowman. The school's namesake introduced the junior high school system to Denver. It was built for a capacity of 2,200 seventh, eighth, and ninth graders. "The perfect beauty of the main entrance has caused it to be spoken of as a poem in architecture," stated the school dedication program. (KFC.)

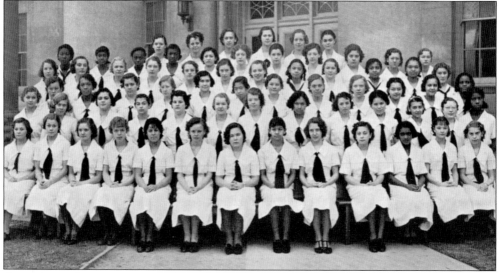

COLE GIRLS, CLASS OF 1936. Indeed, no other Denver junior high school makes its presence more noticeable than the Carlos M. Cole Junior High School. Its beauty is unsurpassed even to the modern day. Eileen Crowder, a member of the class of 1936, wrote in a poem, "Like a key on a silver ring, Cole, you have been to me, opening the gateway of success." The Cole building remains a landmark in the neighborhood, but its future, like that of the Mitchell School next door, remains uncertain. (Author's collection.)

Four

PRAYERS MADE STONE

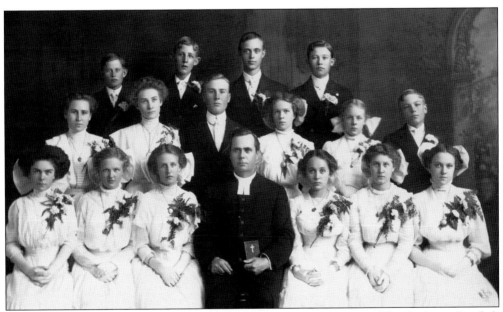

BETHANY LUTHERAN CHURCH, FIRST CONFIRMATION CLASS, 1910. The Bethany Swedish Evangelical Lutheran Church opened in 1908 under the direction of Pastor Robert Acsell. While initial sermons were held in an old chapel built in 1888 at Thirty-eighth Avenue and Franklin Street, the growing congregation wanted a permanent home. "Dr. Acsell was a stern pastor who never chuckled or smiled," commented parishioner Boots Bigelow when looking back on Bethany's long history. In this amazing snapshot in time, devoted students mimic their pastor. (Bethany Lutheran Church.)

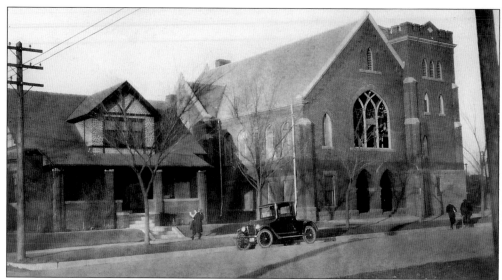

BETHANY LUTHERAN CHURCH AND PARSONAGE, C. 1925. The northwest corner of Thirty-second Avenue and Gilpin Street was chosen as Bethany's new home. A cornerstone was laid in 1910 with 1,500 parishioners gathered. While a parsonage was finished in 1913, a dedication of the completed church did not take place until October 3, 1926. The church's basement was used for services during the intervening years while Dr. Robert Acsell raised funds for the rest of the building. (Ray Acsell.)

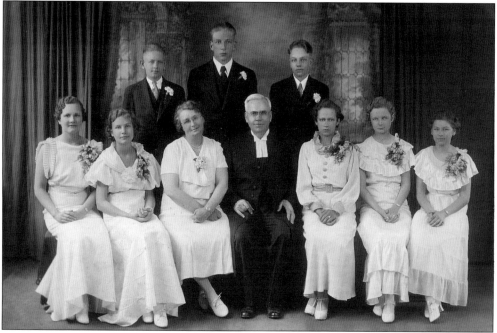

PASTOR ACSELL'S FINAL CONFIRMATION CLASS, 1935. Pastor Robert Acsell retired from his post in 1935. The much-loved pastor even managed to show a smile in this photograph. Gone was the Swedish language from sermons. But the church, with its beautiful stained-glass windows, was left as his legacy. On December 1, 1956, the church was sold to the Denver Gospel Church for $24,000 after the Bethany congregation voted to move to southeast Denver. (Bethany Lutheran Church.)

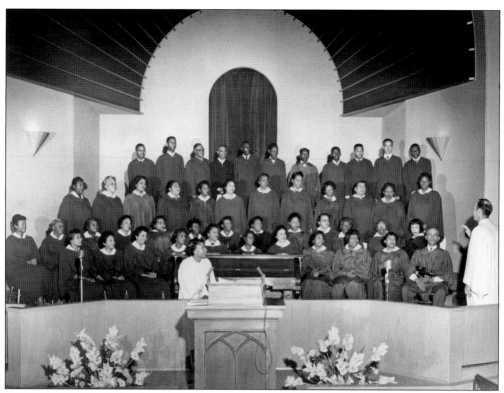

NEW HOPE BAPTIST CHURCH, C. 1950.
The home of the Twenty-third Avenue
Presbyterian Church changed hands in 1948
as New Hope took over the building, and
the shrinking Presbyterian congregation
joined forces with another contingent in
Capitol Hill. Located at Twenty-third Avenue
and Ogden Street, the church had been
rebuilt in 1906 after a devastating fire. New
Hope was founded in 1922 and purchased
the former United Norwegian Lutheran
Church at 2531 Ogden Street as its first
permanent home. (DPL WHC, X-25352.)

**CHRIST METHODIST EPISCOPAL CHURCH,
c. 1890.** Architect Franklin Kidder designed
this stunning edifice at the northwest
corner of Twenty-second Avenue and
Ogden Street. When it opened, it had
the tallest steeple in the city. In 1927, the
Scott Methodist Church attained the
building, naming it for Isaiah Scott, a
pioneer black Methodist bishop. (DMF.)

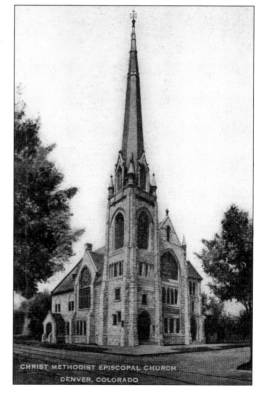

CHRIST METHODIST EPISCOPAL CHURCH
DENVER, COLORADO

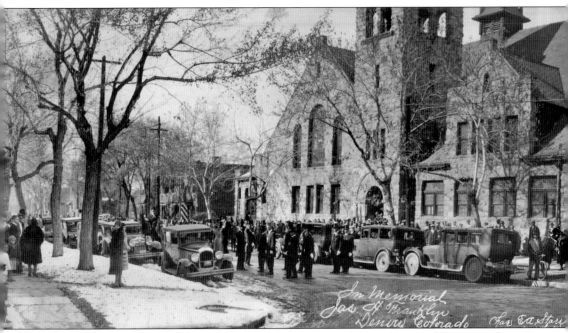

Zion Baptist Church, Twenty-Fourth Avenue and Ogden Street, November 5, 1929. Constructed in 1892, this was the second home of Calvary Baptist Church. In October 1913, the congregation held its last service here. This church was the first in the neighborhood to transfer ownership from a white to a black congregation. Pastor Arthur Finch explained, "The steady advance of the color line caused the Calvary Baptists to sell their old church to Negro Baptists. The old building is a fine one." Zion Baptist is the oldest black congregation in the Rocky Mountain

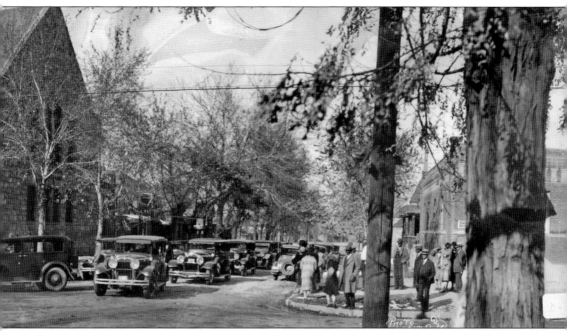

West, having been established in 1865 by former slaves. Leaving their home near Twenty-first and Arapahoe Streets, Zion Baptist proudly moved into "new" quarters and has remained ever since. Interestingly, with so many churches on Ogden Street, Calvary Baptist Church pastor William Jordan petitioned the city to rename the street as Church Street in 1902, but his efforts were to no avail. (Black American West Museum.)

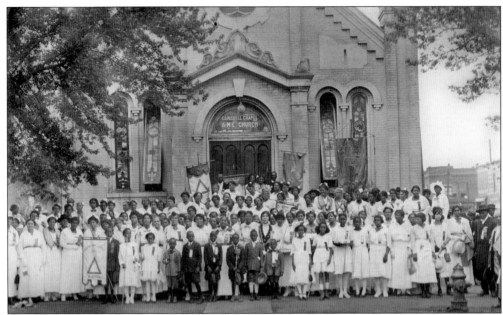

CAMPBELL CHAPEL AME CHURCH, C. 1930. Campbell Chapel was established in 1886. By 1903, worshippers used this church at 2261 Lawrence Street, where they remained until 1934. The former Church of the Holy Redeemer at 1500 East Twenty-second Avenue became their new home. Their prominent neighbor at 2335 Arapahoe Street had been Dr. Justina Ford, who delivered more than 7,000 babies during her long career in Denver. Her home is preserved today as the Black American West Museum. (Salah and Nisa'a Abdullah.)

GALILEE BAPTIST CHURCH SUNDAY SCHOOL, 1893. Long serving the neighborhood, the Galilee Baptist Church is one of the oldest Baptist churches in Denver and was first located at Thirty-fourth Street and Lawrence Street. From left to right are (first row) Edna Wilson, Mary Treverrow Stone, and Freda Kramer; (second row) Helen Hart, Mabel Brown, Fredia Waters, and Gladys Charter. (GBC.)

FARTHER LIGHT MISSIONARY CIRCLE AT GALILEE BAPTIST, C. 1903. The church was officially organized in June 1888 with 23 members under Pastor Charles H. Walker. It was an outgrowth of proselytizing door-to-door, seeking members for a new church—a church in a tent. Soon, however, a building was in place, complete with hitching rails for horses out front. Kerosene lamps lined the walls. This small building remains standing at 3400 Lawrence Street. (GBC.)

PASTOR GRAVETT AND HIS FAMILY, 1905. On May 7, 1891, Pastor Joshua Gravett took the helm of the Galilee Baptist Church. He had arrived in Denver with his wife, Charlotte. Members of the church met them at Union Station and then hailed a hack to take them to their living quarters at 3406 Downing Street. In time, the church grew, along with a family. Shown here are, from left to right, Charlotte, Hope, Dwight, Joshua, Grace, and Ruth. (GBC.)

THE NEW FORD, 1916. Pastor Joshua Gravett, like many people, was more apt to make trips by walking or riding a bicycle. But in celebration of his 25th year at Galilee Baptist, parishioners thanked him in a special way. "His surprise was complete that evening when he entered the church and found the 'decoration' dominating the platform—a model T Ford sedan . . . several mechanics spent hours dismantling it, and again assembling the car out in the street," as retold in *Patriarch of the Rockies*. (GBC.)

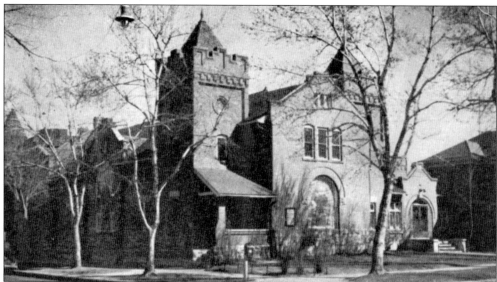

GALILEE BAPTIST CHURCH AT THIRTY-SECOND AVENUE AND HUMBOLDT STREET. Change was coming as growth in attendance necessitated a new home. Pastor Joshua Gravett secured a deal by purchasing the former Hyde Park Presbyterian Church for $9,500 in 1921. The edifice needed some work because it had been partially damaged by fire. Pastor Gravett and church members had the church and the adjacent parsonage at 3144 Humboldt Street ready for full use by the fall of 1922. (GBC.)

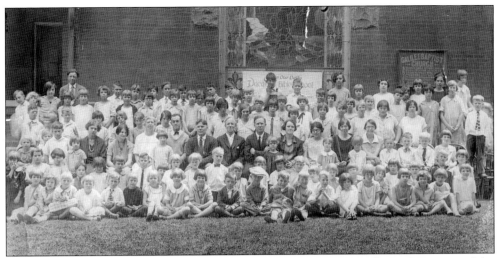

Vacation Bible School, c. 1925. Pastor Joshua Gravett poses proudly in the center of the photograph with his large flock of students and teachers. Attendance surged during the 1920s as neighborhood residents filled the pews, drawn by Pastor Gravett's growing reputation, longevity, and natural charisma. But parking began to be a problem because fewer people were walking to church. (GBC.)

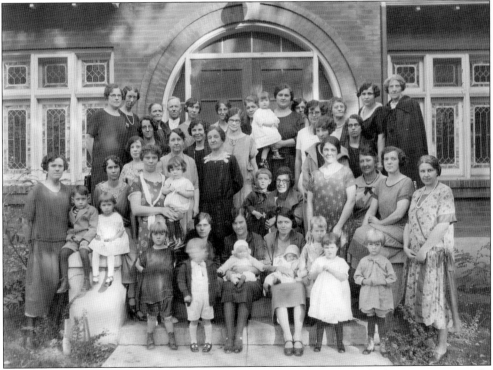

Dorcas Missionary Group, c. 1926. Galilee Baptist Church has always had a strong program for helping missionaries around the world. This started in 1891 when member Allen N. Cameron was sent to China. In addition, Galilee has been involved in the foundations of such Denver institutions as the Colorado Christian University and the Denver Rescue Mission. In this picture, longtime member Mary Treverrow Stone is standing directly in front of Pastor Joshua Gravett. (GBC.)

THE WHITE HOUSE
WASHINGTON

May 1, 1941

Dear Mr. Gravett:

I am very glad to join with the members of
your devoted congregation in congratulating you on
the completion of fifty years as pastor of Galilee
Baptist Church.

It is indeed an unusual circumstance that
you should remain through a full half century with
the church over which you were settled at the time
of your ordination. I am sure you and your congrega-
tion will find great pleasure in a backward glance
at all of the struggles and sacrifices and spiritual
triumphs you have experienced together through this
long ministry.

May I, in extending my hearty congratulations,
express also the hope that you may long be spared in
health and strength to continue your good work for
God, for country and for your fellowman.

Very sincerely yours,

Franklin D. Roosevelt

Reverend Joshua Gravett,
Galilee Baptist Church,
Denver, Colorado.

A LETTER FROM THE WHITE HOUSE, 1941. Letters came pouring in to congratulate Pastor Joshua Gravett on his 50 years of service. Pres. Franklin Roosevelt was one of the more prominent people to send salutations. Member John Brazee said, "Brother Gravett came here as a young man of 27 years . . . he has shared our blessings and our sorrows." His partial retirement came in 1951 after 60 years of leadership. (GBC.)

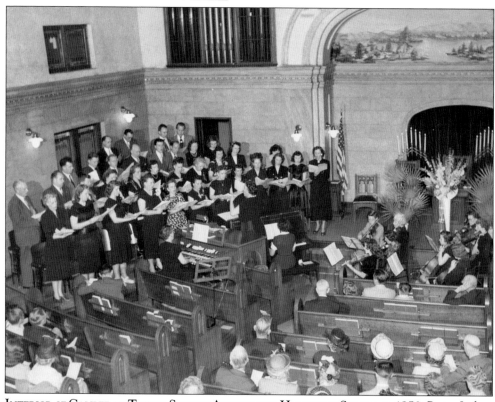

INTERIOR OF GALILEE AT THIRTY-SECOND AVENUE AND HUMBOLDT STREET, C. 1950. Pastor Joshua Gravett died on July 27, 1956, at age 88. In 1952, Galilee Baptist elected to build a new edifice nearby at Thirty-second Avenue and Adams Street. The old building was sold to the Union Baptist Church. Within 10 years, Galilee left once again, this time to southeast Denver. Their third church building was sold to Macedonia Baptist. (GBC.)

Five

A LEAGUE OF PEOPLE

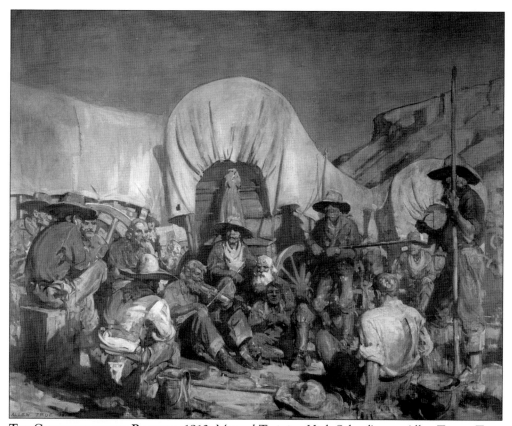

THE COMMERCE OF THE PRAIRIES, 1913. Manual Training High School's own Allen Tupper True, a member of the class of 1899, went on to a distinguished career as a muralist. His works grace four state capitols, including Denver's. His passion for creating scenes from the early West serves as the focal point for many of his paintings. This particular creation enhanced the walls of Denver's first branch library, known as Warren, at Thirty-fourth Avenue and High Street. (DPL WHC.)

ALLEN TUPPER TRUE, C. 1908. Allen True was in London in 1908, serving as an apprentice to Welsh muralist Frank Brangwyn. True's reputation grew as he contributed lasting works of art that can still be seen in such places as the Civic Center Park and the old Mountain States Telephone and Telegraph Building. This is a rare photograph of a young True; his picture from the 1899 Manual Training High School yearbook is missing. (Edith True Marbut Collection.)

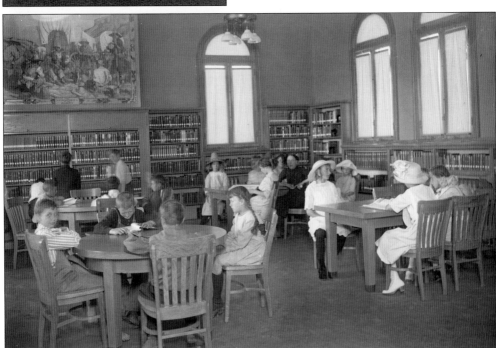

HENRY WHITE WARREN BRANCH LIBRARY, C. 1913. Among other things, Warren was the first Methodist bishop of Colorado. He also was a cofounder of Denver's Iliff School of Theology. Well known and respected in Colorado, Warren passed away in 1912 around the time Denver had received an $80,000 Carnegie grant for branch libraries. This library, designed by Fisher and Fisher architects, had the highest circulation rate of any of Denver's branches for many years. Part of True's mural can be seen in the upper left corner. (CHS, No. 10032126.)

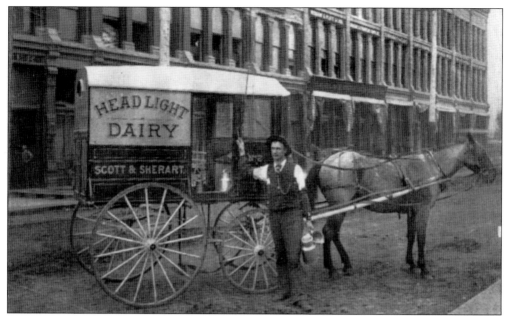

HEAD LIGHT DAIRY, c. 1892. Andrew L. Scott arrived in the United States from Scotland in 1876, the year Colorado became a state. He started selling milk from a horse-drawn wagon, partnering with dairy farmer William Sherart. With proceeds from his door-to-door business, he opened Scott's Market at Thirty-second Avenue and Gilpin Street in 1897. Sometime after 1900, he moved into a building at Thirty-first Avenue and Williams Street. (Bud Scott.)

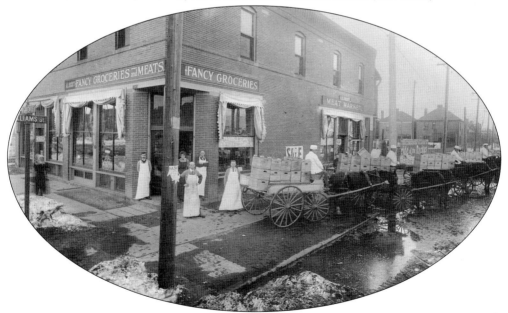

SCOTT'S MARKET, c. 1910. Andrew Scott is pictured in the center, directly in front of the two people in the doorway. John Cox is next to the wagon. He went to work at Scott's Market in 1904. Each week, four wagonloads of products were delivered to the store. Scott's Market provided grocery delivery to area residents and was a reliable vendor of numerous provisions, all easily accessible by walking, carriage, or streetcar. (Bud Scott.)

GLENN ROBERT SCOTT, MANUAL TRAINING CLASS OF 1919. Glenn Scott took over his father's business in 1937 but sold it in 1945 to John Cox. Cox ran the store with his wife, Mildred, until she sold it to current owner Ron Ford in 1976. The Scott's name was retained, honoring this grocery tradition. Ford's continuing dedication has resulted in one of the oldest businesses in Denver being located in Whittier for more than 110 years. (MHS.)

LINCOLN MARKET, TWENTY-FIFTH AVENUE AND GILPIN STREET, C. 1950. Zoning regulations of the mid-20th century undid much of the mixing of uses found in older residential areas. Some of these remnant businesses have remained however. In 1922, the Piggly Wiggly chain opened a shop at 1700 East Twenty-fifth Avenue that is now occupied by the Lincoln Market. Conflicting neighborhood stories abound concerning if a Mr. Lincoln was a real person. Could he be the older man in this photograph? (DPL WHC, MCD-55.)

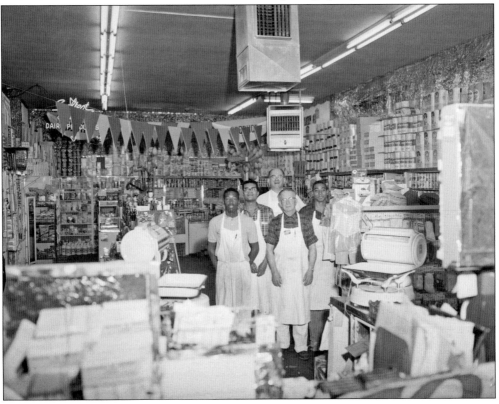

TWENTY-THIRD AVENUE AND HIGH STREET WHEAT FIELD, 1909. "How Denver is stamping out the weed evil," reads this caption from *Denver Municipal Facts*. Thirty bushels were harvested on land that would eventually become homes. Whittier has a rather diverse housing stock, with much of the eastern half of the neighborhood being developed after 1900. The American foursquare, known locally as the Denver Square, is a typical house style found in much of Whittier and dates from this time. (DMF.)

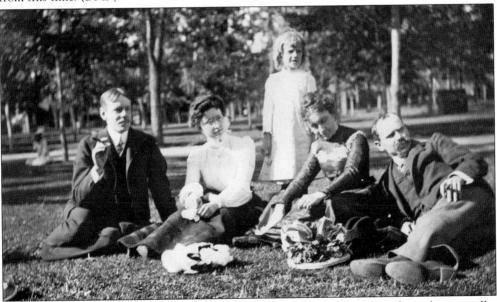

FULLER PARK, C. 1905. Deeded to the city in 1879 by Horace Fuller of Ohio, the park was smaller than at present day, covering only one block from Twenty-eighth Avenue to Twenty-ninth Avenue and from Gilpin Street to Williams Street. Fuller, who originally owned nearly half the land in Downing's Addition, stipulated that the city had to make "a first class park by planting and cultivating trees and shrubs." The girl in the picture is Katherine Hildebrand. (DPL WHC, X-20858.)

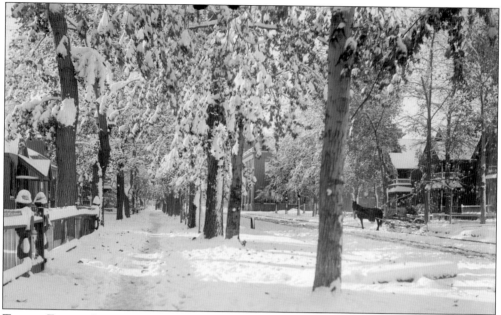

TWENTY-EIGHTH AVENUE AND FRANKLIN STREET, OCTOBER 1905. The "olden days" were coming to an end in this photograph. Once a common sight in Denver streets, the horse and buggy would become an endangered species during the next 20 years as the automobile transformed Denver. A simpler time perhaps, with Manual Training High School in the distance, this view in the Whittier neighborhood has been completely erased from history. (DPL WHC, X-23516.)

3003 GAYLORD STREET, 1918. Carl Albert Weiner, age two, plays in his yard. Built in 1913, this house is among many in a newer part of the Whittier neighborhood. This photograph shows the new homes but the lack of mature trees, a common feature of life in the new suburbs. (Tom Noel.)

ROMEY AND VIOLET BORDIGON, C. 1929.
Brother and sister pose for this photograph
in Denver, dressed up in the style of the day.
Violet would later live at 3030 Lafayette Street
while attending the Carlos M. Cole Junior
High School. Her graduation from Manual
Training High School in 1940 was a proud
day for her Italian immigrant parents, Ernest
and Carmen Bordigon. (Author's collection.)

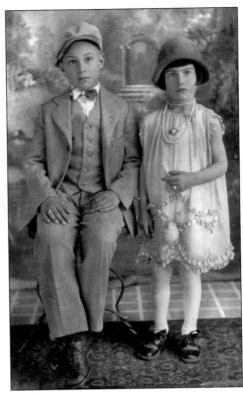

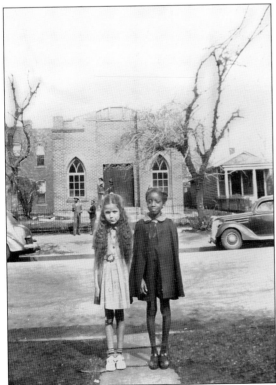

ESTELLITA BARELA AND HER FRIEND
ANNABELLE, C. 1940. Growing up
in Whittier at Thirty-first Avenue
and Lafayette Street with her family,
Estellita (left) was born into the caring
hands of Dr. Justina Ford in 1932.
Although her brothers graduated from
Manual Training High School, the
Barela family left the area in 1943 for
southwest Denver. Estellita graduated
from Scenic View High School in 1952
and eventually raised her own family in
these "new" suburbs, far from the "old"
neighborhood. (Margaret S. Garcia.)

EARL MANN, C. 1942. While Joseph H. Stuart was Colorado's first black legislator, serving from 1895 to 1897, Mann broke barriers when elected to the Colorado House of Representatives in 1942. His election also signified the growing clout of the black community as its population grew in the Five Points and Whittier neighborhoods. Earl Mann (at left) served for five terms. Both he and Stuart fought for equal housing opportunities for all. Mann resided at 2533–2535 Williams Street. (CHS, No. 10039334.)

CARRIE NEEF AT 1739 EAST TWENTY-NINTH AVENUE, C. 1924. The wife of Max Neef, a famous Denver brewer, Carrie (at left) and her family lived in this home from 1883 until 1945. Built in 1881 for Robert E. Schulz, a bookkeeper at the German National Bank of Denver, the home was one of the first to be built across from the new Fuller Park. Schulz only briefly lived in the home. (GKC.)

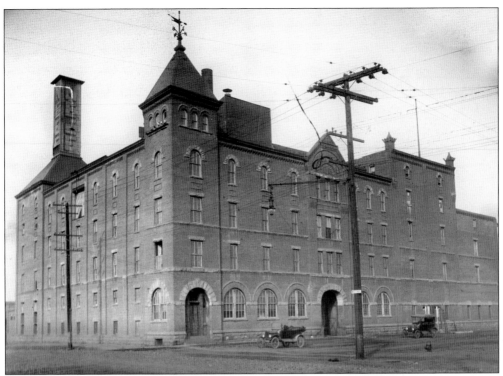

NEEF BROTHERS BREWING COMPANY OF DENVER. Located at the corner of Twelfth Avenue and Quivas Street, the brewery was run by Max and Fred Neef. Opening in 1892, the company grew to be one of the largest breweries in the West. Their Gold Belt beer brand became known nationally. However, when Prohibition arrived in Colorado in 1916, the Neefs were soon out of business. Max passed away in 1921. (CHS, No. 10039261.)

EMMA NEEF, C. 1905. Daughter of Carrie and Max Neef, Emma was born in 1882 and grew up in the house and in the Whittier neighborhood. During her father's 48th birthday in 1898, the *Denver Times* described the festivities held in the home, "Professor Zietz rendered several piano selections, refreshments were served, and at a late hour the guests departed, wishing the host many happy returns of the day." (GKC.)

MAXINE HYLAND, C. 1920. Emma Neef married Robert Hyland in 1912. They lived briefly in a home next door along Twenty-ninth Avenue. In 1918, their daughter Maxine was born. She grew up visiting her Grandma Carrie's house—a home that was also briefly occupied by Frederick Eberley, one of Denver's most prominent architects of the 19th century. He later lived near Twenty-ninth Avenue and Gilpin Street. Among other buildings, he designed the stunning Arapahoe County Courthouse. (GKC.)

MAXINE IN GRANDMA'S BACKYARD. Standing for a photograph in the backyard of Carrie Neef's house, Maxine Hyland (at left) became the third generation of the family to build memories in the old home. At the rear of this photograph stands a home at 2925 Williams Street. The photographic legacy of this family has been preserved thanks to Hyland. (GKC.)

Neighborhood Children Visit the Neefs, c. 1924. This photograph captures the smiles of numerous children as they stand near the porch of the Neef house. Across the street, the legacy of Horace Fuller stands before them. Many of the trees in Fuller Park had been planted by Fuller himself when he visited Denver during the 1880s. He ensured the planting of nearly 2,000 trees in the park and neighborhood. (GKC.)

Carrie Neef and Friends, c. 1924. Carrie (lower left) was able to truly see a neighborhood in transformation over her long life. When she moved into the house in 1883, hers was one of the few homes in the area, and there were no trees. Land that 20 years prior had been the domain of bison, prairie dogs, burrowing owls, lark buntings, and rattlesnakes was now part of a new thriving suburban settlement. (GKC.)

A Neighbor Snoozes, c. 1924. Mr. Heckel enjoys a bit of rest in a hammock in his yard next door to the Neefs. Maxine Neef remembers him as working in lithography. Whatever his occupation, this photograph captures a moment in time that all who look at it can surely identify with. (GKC.)

Carrie Neef and Mrs. Grandmother (Emma) Hyland. The matriarchs of the family pose with the carriage house behind them. By the time Carrie passed away in 1944, what was once new had become old and tarnished. The pace of old families leaving the Whittier neighborhood increased following World War II, while a concomitant shift in the neighborhood's demographics occurred. By 1948, the Neefs' longtime home belonged to Teizo and Minoru Nonaka. (GKC.)

Six

OUR FATHER NEVER LEFT

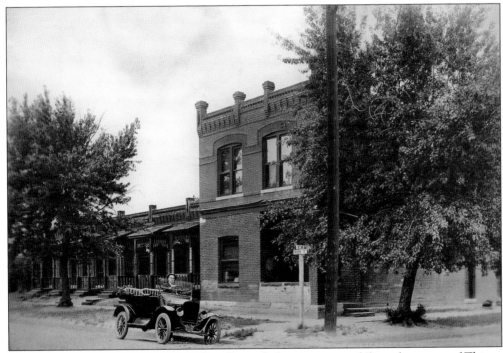

WHEN PARKING WAS EASY, C. 1920. Ray Ott parks his new automobile at the corner of Thirty-ninth Avenue and High Street. Buying the terraces as rental properties and living in the Italianate home, Ott was active in neighborhood real estate. He also ran a sightseeing business. These homes, dating from 1893, still stand in a somewhat modified existence. (VLD.)

A Moment Captured, c. 1920. Born in 1914 in Devil's Tower, Wyoming, Lela Anna Conzelman traveled with her parents at age four via covered wagon to their new home in Denver. They moved into one of the terrace apartments owned by her stepfather Ray Ott. In this picture, Lela stands in front of a phonograph holding her doll and appears fashionable in short hair. (VLD.)

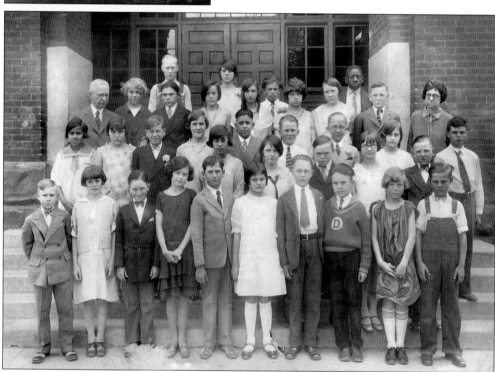

Hyde Park Elementary School, c. 1926. Principal George Washington Wyatt, who served the school from 1913 to 1932, stands at the upper left side of the photograph. Lela Conzelman was able to attend this school because it was only a few blocks from her home. Upon finishing the sixth grade, Conzelman attended the Carlos M. Cole Junior High School. She is in the second row, fourth student from the left. (VLD.)

MANUAL TRAINING HIGH SCHOOL, GRADUATION PROGRAM FOR 1932. During her junior year, Lela Conzelman served as a junior escort during the graduation ceremonies, which were held downtown at the City Auditorium. Pastor Joshua Gravett from Galilee Baptist Church delivered the invocation. Some members of his own congregation were surely graduating that day as well. (VLD.)

CLASS OF 1933. Lela Conzelman graduated from Manual Training High School (MTHS) in 1933 at the height of the Great Depression. The growing diversity of the MTHS student body is apparent. Each student was celebrated with pithy quotes such as, "Evelyn is an active and pretty lass, and a popular girl in the senior class." (VLD.)

THE HAPPIEST DAY, SEPTEMBER 5, 1936. Lela (left) Conzelman's best friend, Ida Hansen (right), served as a bridesmaid. The wedding took place in Hansen's family home at 3536 Williams Street. Conzelman's wedding preparation took longer than expected, and her groom, Edward Van Loon, wondered if he had been left at the altar. Luckily though, Conzelman's manicure only made her an hour late to the small ceremony. The couple lived at the High Street terraces. (VLD.)

THIRTY-SECOND AVENUE AND DOWNING STREET GAS STATION, 1937. Born in Denver on October 5, 1909, Edward Van Loon (left) grew up in the area around Fortieth Avenue and Humboldt Street. His parents were in Denver by the late 19th century. Ed was a friend of Glenn Conzelman, Lela Conzelman's brother. He worked at this gas station before and after their marriage. Despite his tough guy reputation, the two were a match. (VLD.)

LELA (LEFT) AND IDA, FALL OF 1945, CITY PARK.
World War II kept Lela and Ed Van Loon busy.
She worked at the Denver Ordnance Plant, and Ed
worked at the Rocky Mountain Arsenal producing
mustard gas. An outing to City Park however signaled
change. Lela was pregnant with their first child,
Sandra. The two stand upon the *Grizzly's Last Stand*
sculpture on the west side of the museum. (VLD.)

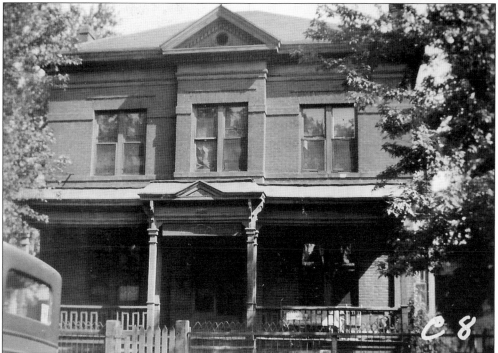

OPPORTUNITY AT 3806 GILPIN STREET. This property was once a large single-family home with
a barn in the rear. Ray Ott purchased the foreclosed home during the Depression. After their
marriage, Lela and Ed Van Loon helped turn the property into apartments, with the barn being
refurbished into their home. Eventually, owning both buildings, the Van Loons rented out the rooms
as a boardinghouse to men who worked at Gardner Denver, a nearby parts factory. (VLD.)

HOME, SWEET HOME. Charging $20 a month next door at the boardinghouse, the Van Loons took up residence at 3800 Gilpin Street after hand digging a basement and applying stucco to the old barn. The loft was made into two bedrooms, with a bathroom as well. Lela, Ed, and young Sandi Van Loon, two years and four months of age, stand outside the front door. The picture was taken on March 28, 1948. (VLD.)

CITY PARK OUTING, SEPTEMBER 7, 1948. For a family that had survived the Depression, the park was cheap entertainment. Lela Van Loon would bring along fried chicken, and the family could enjoy walks or visits to the Denver Zoo. Little Sandi is shown in the front of this picture. The family would also enjoy watching the lights of the large fountain in the lake, as well as listening to live music. (VLD.)

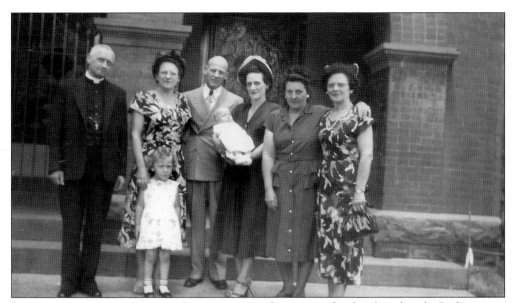

Bethany Lutheran Church, July 10, 1949. Serving as the family's church, Bethany was the site of numerous Easters, baptisms, and church services. In this picture, Lucinda Van Loon is presented after her baptism. From left to right are Pastor S. E. Peterson, Inez Anderson with Sandi Van Loon, Ed Van Loon, Lela Van Loon holding Cindi Van Loon, Ivy Kladder, and Clara Evelina Ott. (VLD.)

First Steps in a New Direction. Young Cindi Van Loon brushes up on her walking skills as sister Sandi looks on, along with friend Albert Nazaranus. In this picture, Sandi is five years old, and Albert is about eight years old. For years, Lela Van Loon worked with Albert's mother at Denver's own homegrown business, Russell Stover Candies. (VLD.)

Sandi and Cindi Van Loon with Easter Baskets, April 9, 1950. Easter was always an important holiday for the Van Loon family. It was on this occasion that the Van Loon daughters would receive one of their new dresses for the year. Lela Van Loon was an excellent seamstress and dressmaker, thanks in part to her time at Manual Training High School. Lassie stands guard at the front door. The boardinghouse appears to the left. (VLD.)

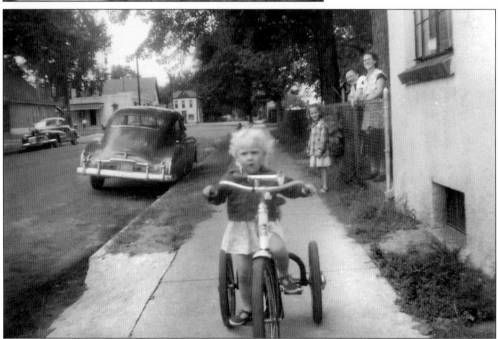

Another Milestone Conquered. Cindi Van Loon practices her skills on a tricycle in about 1952. Sandi watches her sister along the sidewalk and Thirty-eighth Avenue. In the background, Inez Anderson (left), the girls' aunt, and their mother, Lela, look on with encouragement. The Van Loons enjoyed nearby neighborhood shopping within walking distance. A short drive to Miller's Supermarket at Forty-second Street and Brighton Boulevard was common too. (VLD.)

CINDI VAN LOON'S FOURTH BIRTHDAY. Birthdays were always a special occasion for the girls. Lela Van Loon's birthday cakes would always have little figurine decorations on them such as Hansel and Gretel or Cinderella. The girls could choose which decoration to use each year. Cinderella came with the horse, carriage, fairy godmother, and prince. (VLD.)

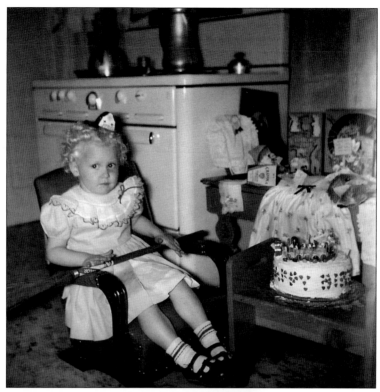

OUR DEAR CLAUDIA IS BORN, AUGUST 5, 1952. Sandi and Cindi Van Loon hold baby Claudia. The girls took delight in helping their mother, Lela, care for their baby sister. On one occasion, Lela told Sandi to throw Claudia over her shoulder so she could burp her. Poor Sandi took her mother too literally and indeed threw the baby. Luckily for all involved, Claudia was not injured. (VLD.)

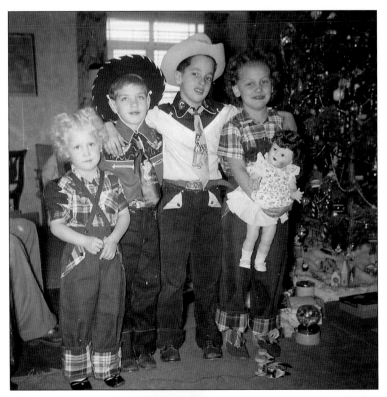

A Very Western Christmas, 1952. Sandi Van Loon remembers holding her Saucy Walker doll and wearing her Donald Duck slippers. She and Cindi Van Loon are standing with friends who are sporting trendy Western attire, including a Roy Rogers tie on the boy on the left. During this time, Hopalong Cassidy, Gene Autry, and others were popular, as was the growing interest in Western movies and television shows. (VLD.)

A Sunny Easter, 1953. With Easter baskets in hand and services at Bethany Lutheran Church, another Easter memory was made. From left to right are Barb Schultz, Joanie Schultz, Mrs. ? Johnson with Claudia Van Loon, unidentified, Carol Schultz, Albert Nazaranus, Cindi Van Loon, and Sandi Van Loon. Cindi is four years old, and Sandi is seven years old. (VLD.)

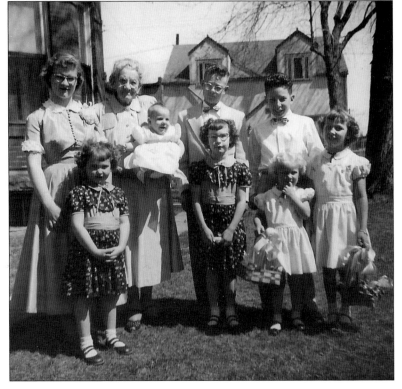

SANDI AND CINDI VAN LOON ARE WITCHES, HALLOWEEN, 1954. Yearly traditions included a parade at school. Both girls attended the same school as their mother, Lela. At lunch, the girls would come home and change before returning to school. For these costumes, Lela made everything but the masks. In the evening, limited trick-or-treating included walks up Gilpin and Williams Streets. Lela would make popcorn balls for the kids who came to her house. (VLD.)

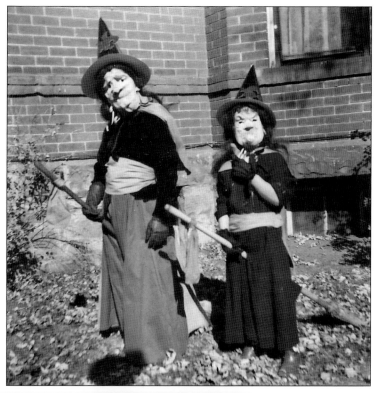

EVERY GIRL MUST LEARN THE ACCORDION. This tradition was carried on by both Sandi and Cindi Van Loon. In this picture, Sandi, Claudia, and Cindi Van Loon prepare for the Memorial Day parade on May 30, 1955. They were part of the VFW accordion band. Over the years, they were in numerous parades and traveled extensively across Colorado to take part in various accordion bands. (VLD.)

MOTHER'S DAY, 1956. Sandi, Lela, Claudia, Cindi, and Ed Van Loon gather on the couch during this special day. The family is enjoying time together and has purchased a nice corsage for their Lela. The curtains in the background would soon travel with the family to a new residence. Lela was excited to be leaving, but Ed had hesitations. Across the country, however, future growth and prosperity was envisioned in expansive lawns and new housing. (VLD.)

70 YARROW STREET, C. 1957. The Van Loon family relocated to the suburbs. Ed, however, longed for the neighborhood he had known his entire life. They retained ownership of the old properties. He went over every week, to "work." Though he would live on Yarrow Street the remainder of his life, in researching this book, the author learned that Ed's heart was always back on Gilpin Street. In the words of his oldest daughter, "He never left." (VLD.)

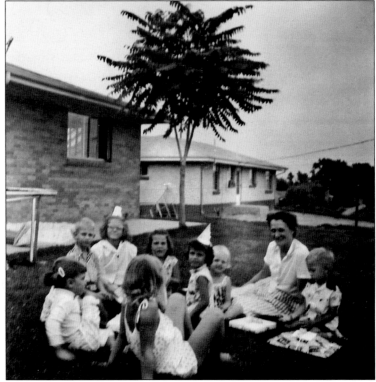

Seven

MUCH MORE THAN ITS NAME

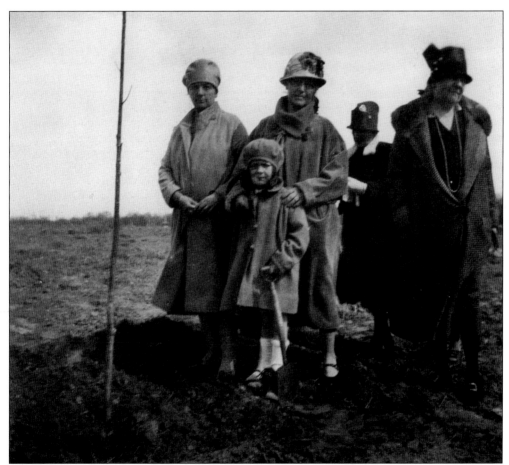

CITY PARK, APRIL 17, 1928. Mrs. ? Greenlee (left), Mrs. W. C. Ferrill with little Anne Ferrill (center), unknown, and Mrs. Frost C. Buchtel (far right) plant a young oak tree, part of an ongoing effort to bring shade to the former dominion of the sun. In order to turn the short-grass prairie into a shaded oasis, two ingredients were needed: trees and water. (DMNS.)

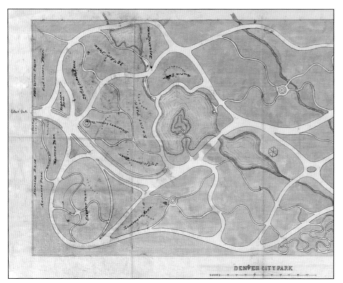

MAP ATTRIBUTED TO HENRY MERYWEATHER AND WALTER GRAVES, C. 1882. This early plan for City Park advocated carriageways and walking paths. This southwestern section of the park plan shows where early Denver schoolchildren began planting trees. This occurred during the first Arbor Day in April 1884. In the Whittier section, an "X" marks the spot where the Whittier Oak was planted. Many schools participated, including Ebert, Longfellow, and Arapahoe. (DPL WHC, WH1316.)

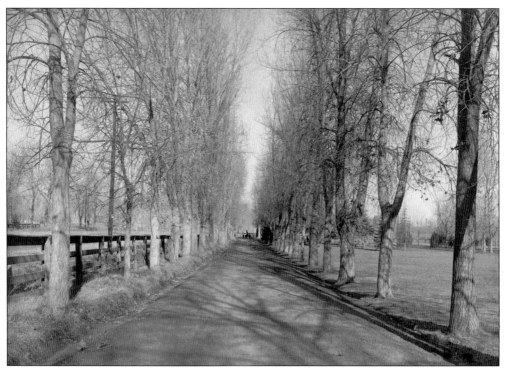

TREE-LINED AVENUE IN CITY PARK, 1902. Ernest Lundberg snapped this image of the successful shading of City Park. Edwina Fallis recalled planting trees in 1884 with her classmates from the Broadway School, "There were a few willow bushes along the big ditch that ran across the upper part of the park, but other than those there wasn't a tree or bush in the whole place, just cactus and sage brush and buffalo grass." (DMNS.)

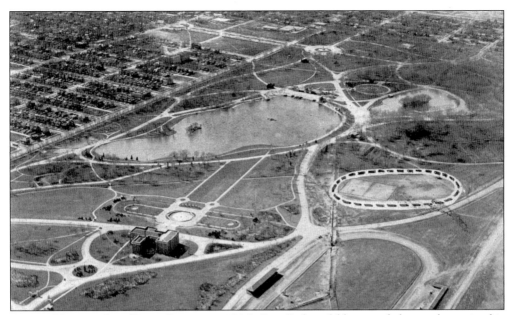

AERIAL VIEW OF CITY PARK, SPRING OF 1924. City Park unfolds toward the southwest in this photograph. The amenities shown, including the museum, Gentlemen's Driving and Riding Club, boulevards, trees, and lakes, were mere visions on an empty prairie when the park was conceived. Some landmarks are gone today, but City Park is still a key ingredient in the life of the city of Denver that has grown up around it. (DMF.)

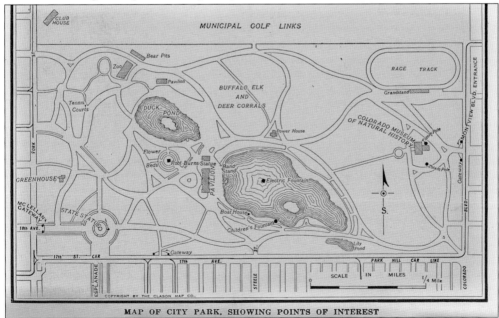

CITY PARK MAP, C. 1925. Reinhard Schuetze was Denver's landscape architect beginning in 1893. He transformed Denver's parks into wooded and watered retreats. While some trees were already planted and a small lake was in place, Schuetze set his sights on a big lake, large gardens, space for a museum, and grand park entrances. His legacy remains mostly intact. He and his wife, Amelia, resided in the Whittier neighborhood at 2335 Humboldt Street. (Author's collection.)

MAYOR ROBERT SPEER TRANSFORMED DENVER. Influenced by the City Beautiful movement, Speer encouraged Denverites to "Give While You Live." Such endeavors helped achieve his vision. Modern Denver began to take shape in ways both large and small. During his administration, millions of trees were planted. This photograph, captioned "How Trees Are Being Moved in New Section of City Park," demonstrated the latest technology for moving large trees in 1909. (DMF.)

AUTUMN DAYS, 1909. Denver's salubrious climate beckoned with the promise of renewed health in a land where the air was thought to be so pure that one could live forever. Denver offered a number of ways to step into the sunshine, from a relaxing boat ride on City Park's lake to a vigorous flirt with the speed and danger of a race at the Gentlemen's Driving and Riding Club. (KJC.)

AUTUMN IN CITY PARK.
City Park offered a haven to the overworked and weary folk of Denver no matter what time of year. Printed about 1930 and written by Saco R. DeBoer, who was the city's landscape architect after 1910, this small item helped the people of the city remember a bastion of "oriental" serenity in its midst at a time when the city and the country were experiencing tumultuous times. (DMF.)

Autumn in City Park

THERE is a briskness in the air, a feeling of moisture, though the sun shines. City Park is aglow with color. One needs walking boots and a cane to enjoy the park in autumn. The giant cottonwoods seem higher than ever in their cloak of yellow leaves. The stems are dark and deeply grooved the bark. The elms are still green and the black locust tree disdains the discolored leaves and also remains green. The spruces seem bluer, the firs darker green.

Under foot dry leaves rattle on the grass, but over the open meadows lies still the hue of green, green as in summer. The lacy leaves of the birch and its slim and slender branches are as graceful as in summer.

The lake is dark and blue, it seems serious and serene. A weeping willow has caught the spirit of autumn. Its calm is truly oriental. Nothing but repose and rest lies in the quiet contemplation of its own picture in the water mirror.

Colors are reflected in the lake, yellow, red and green, and orange, subdued and soft.

The autumn air is brisk, with a feeling of moisture. Put on your walking shoes and swing your cane.

FLOWERS ABOUND! City Park hothouses grew a myriad of flowers for all Denver parks. This 1909 floral arrangement bore witness, perhaps, to the National Education Association that was no doubt visiting Denver for a convention. During this time, a quick ride on the streetcar would bring conventioneers from downtown out to the park to enjoy the growing amenities of this oasis on the prairie. (DMF.)

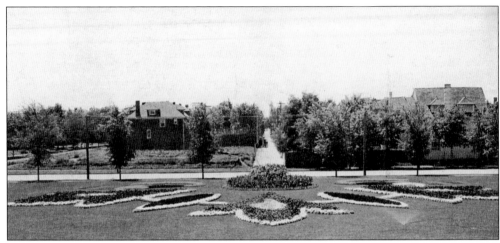

COLFAX AVENUE, A RESIDENTIAL STREET, 1910. The grand southern entrance to City Park was along a road called the Esplanade, which ran perpendicular to Colfax Avenue. The main east-west highway through Denver, Colfax grew rapidly with the arrival of the automobile. By 1917, the floral tapestries had disappeared to make way for grand monuments, fountains, and, of course, better access for the automobiles. (DMF.)

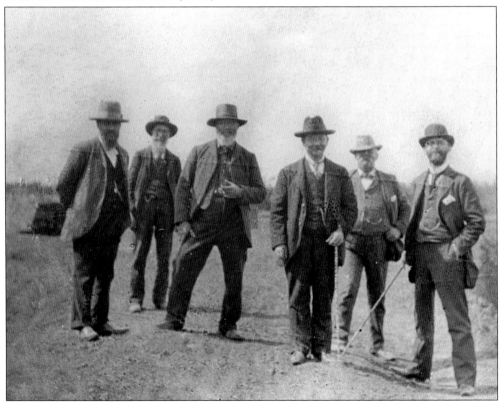

EARTH MOVERS, C. 1896. While the smaller Duck Lake (a converted, natural wetland) was in place around 1889, Reinhard Schuetze had grander plans for a larger lake and other smaller water features. In this picture, the caption states, "Park Commissioners viewing construction for dam for lake at City Park." Teams of mules did most of the work. (Denver Water.)

THE BIG LAKE, C. 1896. In order to have a reliable supply of water for these lakes, the City Ditch was used. Meandering through Denver and originally used by farmers, the City Ditch runs through City Park and again returns to the Platte River. This irrigation was essential for the greening of City Park. In this picture, as the captain states, "Excavation of trench for puddle cone wall for dam" is underway. (Denver Water.)

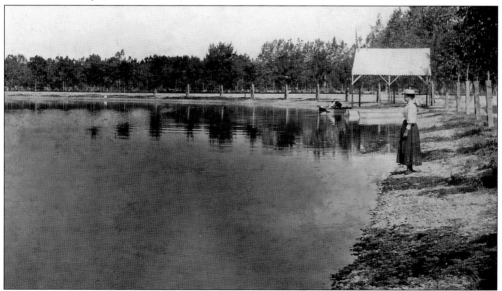

ENJOYING THE NEW LAKE, C. 1897. This unidentified woman stands next to the new lake in an early picture of City Park. Schuetze's plan produced a defining feature of City Park. It served not only as a new haven for waterfowl, complete with a small island in the middle of the lake, but was also used for irrigating the park itself. (Tom Noel.)

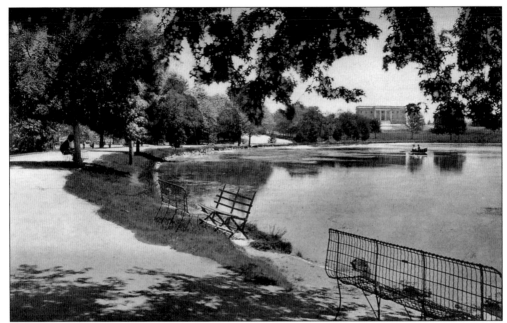

VISTA IN CITY PARK, C. 1905. The relative aridity of the High Plains is not evident in this postcard. After the trees had grown and with easy connections via streetcar or carriage ride, the lure of shade and the coolness of water drew people. Whether resting by the water or admiring the view of the new museum, City Park offered excursions for many tastes and temperaments. (KJC.)

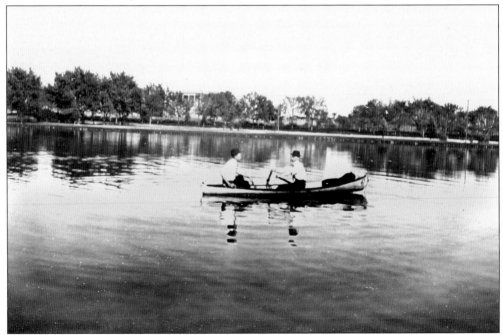

TWO MEN ENJOYING THE LAKE, SEPTEMBER 1911. Real-photo postcards were a popular mechanism for sharing visual accounts of one's travels. This image shows one of the most popular activities at City Park, boating on the large lake. A boating concession had been awarded in 1897; the water was alluring, and there was money to be made. (KJC.)

FLORENCE FEEDING THE DUCKS PEANUTS, JULY 22, 1913. City Park was one of the city's top tourist attractions. This real-photo postcard shows the park's popular Duck Lake. On the reverse, Florence added, "A reminder of the very happiest period in my life." No matter how hard the times, visitors to Duck Lake have always had a wealth of old dried bread to feed the park's fattest denizens. Today it is illegal. (KJC.)

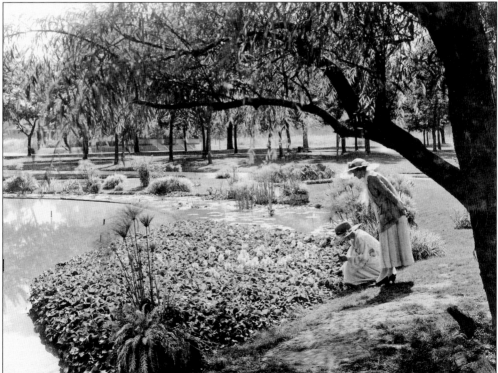

LILY POND, C. 1920. The first lily pond in City Park had the largest collection of lilies west of the Mississippi at the time, but it suffered from contaminants washed from a nearby roadway. A second pond, located more strategically, was decommissioned in 1970 due to lack of space to overwinter the plants. The blossoms and cacophony of birdsong that emanated from them drew many visitors to their shores. (DPL WHC, X-27288.)

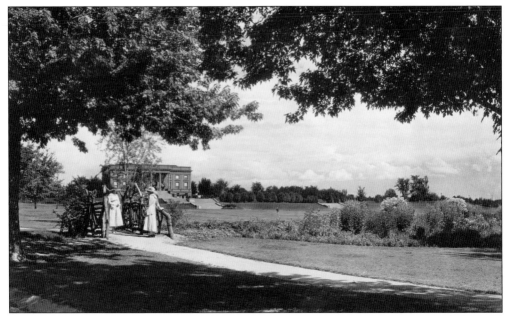

WALKING IN CITY PARK, C. 1915. Walking and cycling were suitable exercises for ladies and gentlemen, and City Park provided an ideal venue. The picturesque wooden bridge to the north of the large lake can be seen, with the western face of the museum in the background. The partially seen dirt road in the lower left corner remains today, though now paved. The wooden bridge, though, does not remain. (DMNS.)

GRANDSTAND, AUGUST 14, 1909. The Gentlemen's Driving and Riding Club was located in the northeastern corner of City Park. The buildings devoted to racing included a cooling shed, an area for judges, and stables that could be privately maintained. Conceived in 1892, the track saw numerous awards given out, including the Daniels Cup, awarded by local merchant William Cooke Daniels for the largest number of harness race wins. (DMF.)

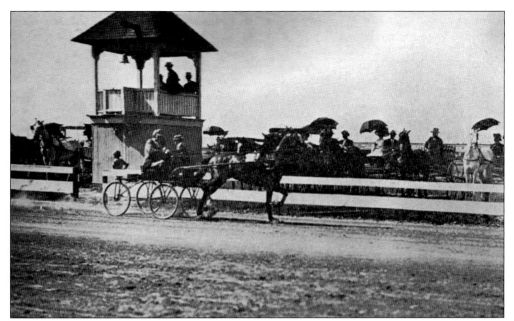

ANYTHING THAT CAN BE RACED WILL BE RACED, 1910. Horse Teddy Weaver leads driver A. J. Simmonson to victory in the 2:17 pace category. Simple horseback racing was also popular at the track. "The races are of a high class. Betting on results or wagers of any kind are not permitted," read the *Denver Municipal Facts* of August 13, 1910. Some matinees saw as many as 5,000 people attend. Automobiles later used the track until it was dismantled in 1950. (DMF.)

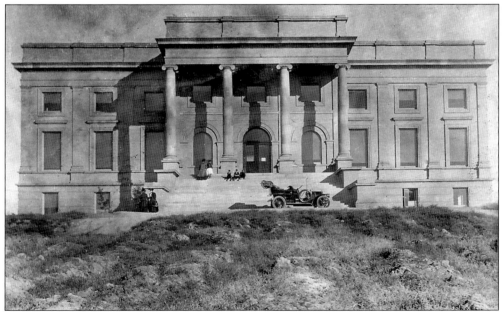

COLORADO MUSEUM OF NATURAL HISTORY, C. 1908. Self-taught naturalist Edwin Carter was the impetus for the museum's creation. Visitors to Colorado would frequently visit Carter to view his collection. After Carter sold his collection to Denver, a museum was begun about 1901 to house it. Dedicated in 1908, only about 12 percent of the museum's items were on display. Nevertheless, it proved an immediate success with the public. (KJC.)

SCHOOLBOYS IN KNICKERBOCKERS, 1912. Ever eager to increase Denver's respectability in the eyes of the rest of the country, many people within the community contributed to the museum's collections. Sen. Lawrence Phipps donated this piece of 17th-century Venetian armor. The schoolchildren of Denver had the opportunity to experience the natural and man-made wonders of the world during field trips to the museum. (DMF.)

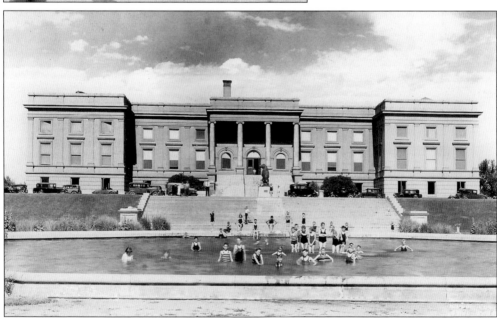

THE MUSEUM HAS NEW WINGS. A north wing (at left) was opened in 1918 and donated by the Joseph Standley family. By 1928, a matching south wing was dedicated to William H. James. Both sides became filled with stunning animal dioramas that had been collected, prepared, and displayed by the museum's own staff during the 1920s and 1930s. The museum expanded again with the addition of the Lawrence Phipps Auditorium in 1940. (KJC.)

MUSEUM TOTEM POLE, JUNE 1921. Not all of the museum's acquisitions were roped off from the public. Many provided as much tactile fascination as they did an ideal opportunity for a photograph. Two totem poles occupied space on the museum grounds. They were eventually moved indoors to be out of the elements and away from the hands of the public. (KJC.)

THE CARLETTIS IN CITY PARK, 1922. From left to right are Lucille, Dario, and Giovana Carletti. They rest by the fountain behind the museum. Italian immigrants and their descendants were influential in shaping Denver after 1900. Many Italians lived in northwest Denver, dubbed "Little Italy," but all people would travel to east Denver to visit City Park. It was a place where all could mix freely. (Nicolette Dreith Rounds.)

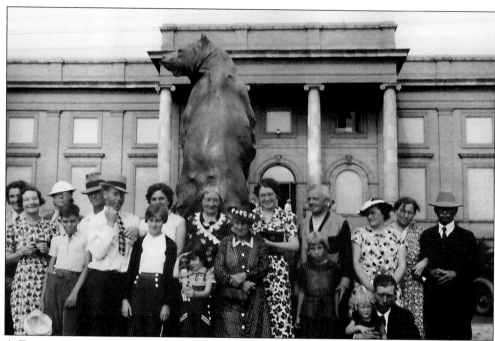

A FAMILY TRADITION, C. 1945. As with many families, a visit to the museum was a special occasion. In this picture, the Maul and Schoeneweis families pose next to the museum's iconic bear statue, known as *Grizzly's Last Stand*. It was sculpted by Louis Paul Jonas in 1930. Although currently in a less prominent location on the museum's grounds, the statue remains a favorite photographic opportunity. (Carl Maul Family Collection.)

THE VIEW WEST, C. 1896. This view, taken from the new pavilion and looking toward the mountains, is missing more than grown trees. Statues and armaments, which would later occupy the land immediately to the west, have not yet been placed. The park was gradually expanding its refinements eastward; there would be much filling in along the way, even as the trees grew overhead. (DMNS.)

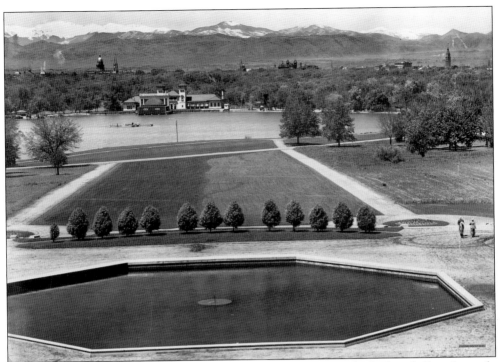

THE BEST SKYLINE VIEW IN TOWN. The museum was located on the highest hill in the park. Reinhard Schuetze was responsible for this important detail. As the museum was being built, the state capitol was also nearing completion. The views from the west side of the museum afforded a stunning perspective of Mount Evans, as well as the pavilion, capitol dome, and Denver's tallest building, the Daniels and Fisher Tower, which was completed in 1912. (CHS, No. 10039335.)

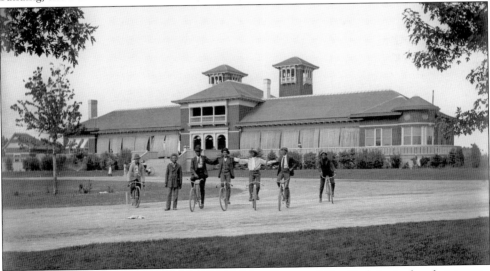

BICYCLING IN CITY PARK, C. 1910. The fanciful walkways of City Park invited pedestrians to dally, but not all of them went so slowly. The byways were also well suited for bicycle exploration. Smartly dressed for a day out and wearing hats in keeping with the fashion of the day, these gentlemen pose with their two-wheeled conveyances with the large pavilion behind them. (DPL WHC, X-27294.)

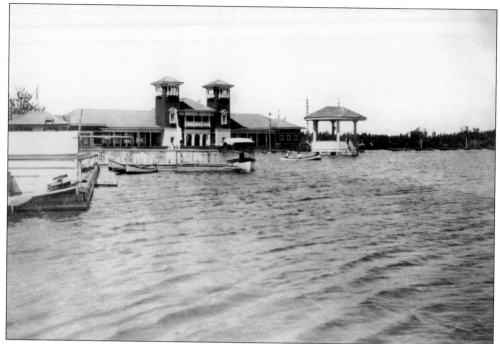

EARLY PAVILION. Since 1896, the pavilion has anchored the western edge of the big lake. It has gone through several alterations, including being encased in stucco during the 1930s. It has served in many roles over the years, including as a dance floor, a dining area, an office, and an event space. Also pictured is the popular dock and boating concession, which was absent for much of the lake's 20th-century existence. (KJC.)

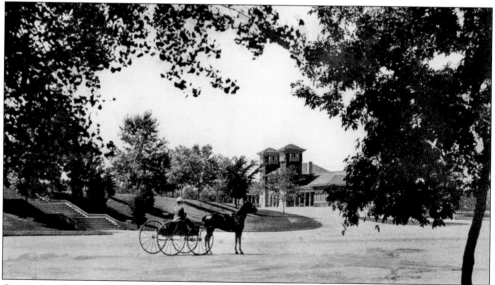

OUT FOR A DRIVE. The April 1910 edition of the *Denver Municipal Facts* offered the following breathless description of the park's beauty, "The effect on a summer evening with the lake and esplanade illuminations shining in all their glory cannot help but be delightful." Citizens from every corner of Denver made City Park their playground, coming by foot, streetcar, horseback, or carriage throughout the year. (KJC.)

THE FLOATING BANDSTAND, C. 1900. Also built in 1896, but later torn down and replaced, this structure served as the venue for many live musical performances. Famed German cornet soloist and conductor Herman Bellstedt made music in Denver from 1892 to 1912. His famous band was one of the top attractions to use the floating bandstand. Many smaller boats would circle it during performances for a better view. (GKC.)

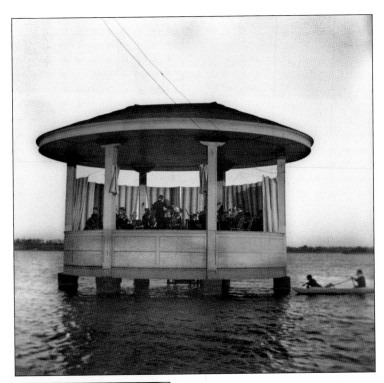

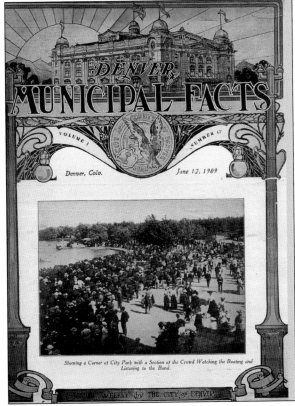

Showing a Corner of City Park with a Section of the Crowd Watching the Boating and Listening to the Band.

DENVER MUNICIPAL FACTS, JUNE 12, 1909. Used at least in part as Mayor Robert Speer's propaganda tool, *Denver Municipal Facts* has become an important chronicler of the city's history. Music was a profound inducement that drew many people to City Park. Free concerts took place in the park as early as the 1880s and became regularly scheduled in 1894. All concerts were free and ran the entire summer. (DMF.)

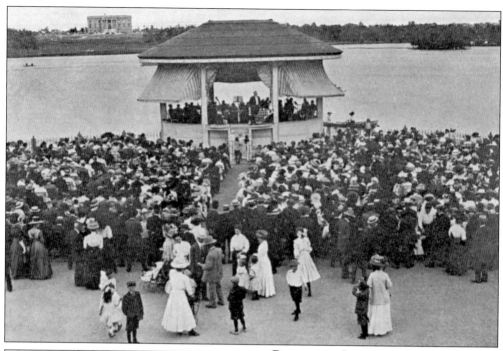

BANDSTAND, LAKE, AND MUSEUM, 1910. Having achieved success in the Spanish-American War, the United States experienced a wave of patriotism in the early 1900s. Katharine Bates's poem "America, the Beautiful," written about a view from Pikes Peak, premiered with its current musical accompaniment the same year this crowd gathered in City Park for Flag Day in 1910. The evening's performance included patriotic songs and fireworks. (DMF.)

SPEER'S VISION, 1916. Mayor Robert Speer said, "I often wish that I could come back in 50 years and see the progress which is sure to be made. Every act which adds to a city's beauty, or man's earthly betterment, starts pulsations for a higher civilization, which pulsations will go on and on, long after we have passed away, and finally reach us again, whether they have to go up or down to find us." (KJC.)

DENVER MUNICIPAL BAND PROGRAM, JULY 20, 1916. An interesting advertisement for Ford's shows the Eastman Kodak Brownie Camera for sale. Ford's would also develop film. Barnes Commercial School, later the Barnes Business College, long served the Denver community as well. It is assumed that the misspelled "potatoe" was done on purpose. (KJC.)

Thursday Night, July 20, 1916
Soloist—L. L. HANDZLIK, Cornet

1. From Pagliacci ... Leoncavallo
 a. Prolog; b. Bell Chorus; c. Bird Song
2. Freut euch des Lebens—Waltz Strauss
3. a. Baby Shoes—Song for Trombone Piantdosi
 b. Oh! What a Beautiful Baby Brown
4. Overture—Zanetta ... Auber

Tomorrow Night, July 21, Tschaikowsky's Symphony, No. 6, The Pathetic, will be given entire for the first time by any concert band in the world.

PART II

5. Welsh Folk Songs—Fantasy Gwyllyms
6. From A Midsummer Night's Dream Mendelssohn
 a. Scherzo; b. The Wedding March
7. Sea Shells Waltz—Cornet Solo Innes
 HANDZLIK
8. Merry Wives of Windsor—Overture Nicolai

The C. G. Conn Band Instruments are endorsed and used by Mr. Innes and the members of the band.

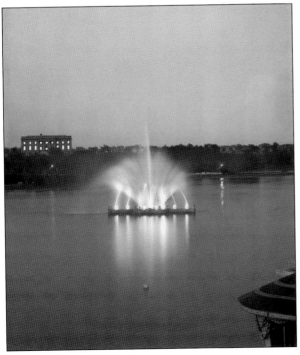

WATER, COLOR, AND LIGHT, c. 1909. Installed for the 1908 Democratic National Convention, held in Denver, the citizenry was dazzled with colorful light shows in the lake. *Denver Municipal Facts* stated in August 1910, "The fountain appears to be an attraction of which the people never tire." It was created by Fred Darlington, a Denver Interurban Railroad Company engineer. (DPL WHC, MCC-923.)

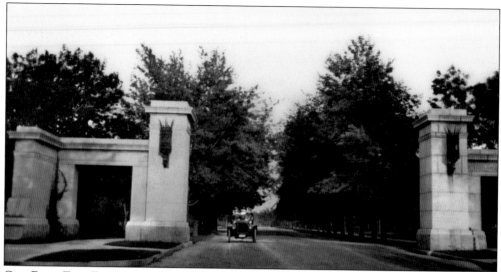

CITY PARK, EAST EIGHTEENTH AVENUE ENTRANCE, 1909. The McLellan Gateway honors William W. McLellan, considered the "Father of City Park" for having introduced the legislation to purchase the land for the park during his time as city councilman. He gave half of his savings to construct the gate, wanting to do something for Denver. Opening in 1904, the McLellan Gateway cost $13,700 and spurred other citizens to beautify their city. (DMNS.)

1859 YORK STREET, C. 1910. The western border of City Park is formed by York Street. Today a busy north-south artery, it was once a dirt road lined with mansions on the west, looking into the park. Such was the McPhee-McGinnity Mansion, constructed for businessman Charles McPhee in 1905. The columns from the home appear on the right side of the photograph. The McLellan Gateway can be seen in the distance. (DPL WHC, MCC-559.)

CASHING IN ON CITY PARK, JULY 2, 1910. Three gentlemen pose in their two-dimensional vehicle, complete with right-side steering wheel and a crank to start the engine, in this image taken in Denver. The photograph, sent to a Ms. G. Jones of Lamar, Colorado, shows the McLellan Gateway behind. While William W. McLellan was known for his civic service, no known picture remains of this man who gave future generations so much. (KJC.)

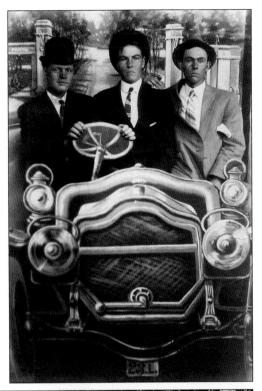

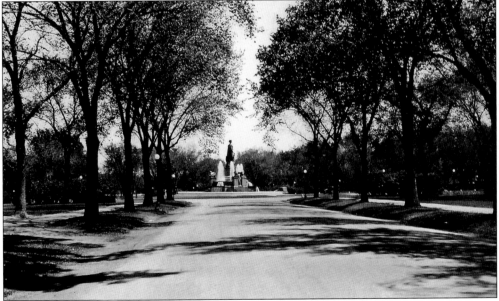

THE CITY BEAUTIFUL. The Eighteenth Avenue entryway connected directly to downtown. Visitors would have seen the Joseph Addison Thatcher Memorial Fountain from an impressive distance. However, to accommodate growing automobile traffic, both Seventeenth and Eighteenth Avenues were turned into one-ways into and out of downtown. Thus the gateway was closed to traffic, and a portion of the park was removed, along with numerous trees. In 1957, the magnificent McLellan Gateway was moved to its present location at Twenty-first Avenue. (KJC.)

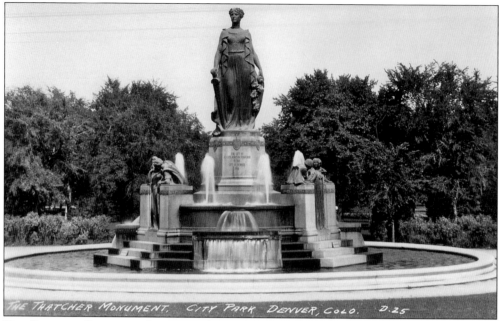

THE STATE OF COLORADO STATUE, A GIFT FROM THE LIVING. The Joseph Addison Thatcher Memorial Fountain was dedicated on September 14, 1918. Arrayed around the 18-foot statue of the State are three supporting virtues: Loyalty, Learning, and Love. Fountains of varying heights complete the effect. Sculptor Lorado Taft, in a 1917 *Denver Post* interview, stated the fountain was "executed with dignity and majesty that will last throughout the years." (KJC.)

THATCHER MODEL. Annette Katherine Ryder served as the model for the central figure of the Joseph Addison Thatcher Memorial Fountain. The statue represents Colorado bearing the sword and shield of the state's citizens. The fountain occupied a premier spot, at the intersection of two primary entryways: Eighteenth Avenue, leading east from downtown, and the Esplanade, which led north from Colfax Avenue, Denver's main east-west arterial roadway. (Tom Noel.)

LOYALTY. As this photograph from 1918 shows, Denver was building a civilization fit for the ages. " 'Loyalty' portrays a young knight in armor leaning upon his broadsword, while above him bends the figure of 'Peace' with an olive branch in her hand, pointing out to him the better way. The discarded helmet with laurel betokens his past victories," stated the October 1918 *Denver Municipal Facts.* (DMF.)

LEARNING. The October 1918 *Denver Municipal Facts* explained, " 'Learning' turns her head to a youth who has closed his book to ask a question, while a little girl perched upon a pile of books is busily ciphering upon her slate. The main figure has a benign face and is draped in a scholastic garment." (DMF.)

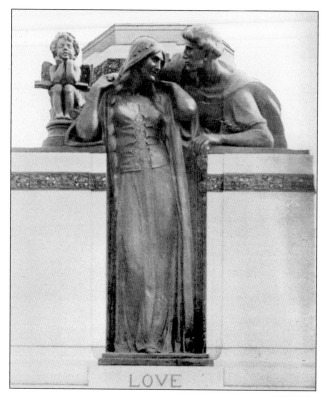

LOVE

LOVE. The October 1918 *Denver Municipal Facts* went on to state, " 'Love,' foundation of the home and the state, suggests a young girl whose sweetheart seeks to embrace her, yet modestly she lowers her eyes. A mischievous little Cupid presides over the incident. The entire group is considered by artists to be most striking and imposing." (DMF.)

JOSEPH ADDISION THATCHER. Spending $100,000 of his own money on the fountain was comforting to Joseph Thatcher. He passed away soon after it was officially dedicated. Thatcher was a Denver pioneer and respected banker. He had founded the Denver National Bank in 1884. Upon his death, an elementary school in south Denver was also named in his honor. It closed in 1982. (DPL WHC.)

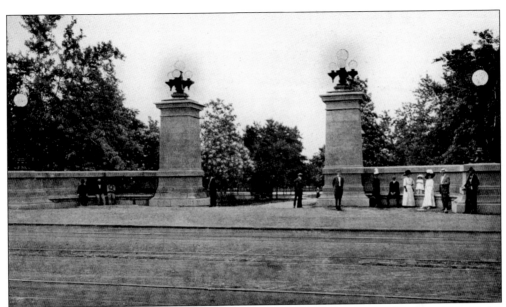

RICHARD E. SOPRIS GATEWAY. Dedicated in 1912 to memorialize the other "Father of City Park," the gateway was designed by famed architect Frank Edbrooke. It stands along Seventeenth Avenue near Detroit and Fillmore Streets, where there was originally a streetcar stop. Today the red sandstone Sopris Gate is overshadowed by trees and marks no significant entry point into the park. It is now passed by joggers and automobile traffic largely unnoticed. (KJC.)

RICHARD E. SOPRIS, '59ER AND MAYOR OF DENVER. Sopris was mayor between 1878 and 1881. He chose the site for City Park. He became park commissioner in 1881 and hired Henry Meryweather to begin plans for the park. Sopris pushed for using design principals followed by Frederick Law Olmstead, who contributed so much to New York's Central Park. Sopris also carefully researched other varieties of trees that would survive in the open prairie. (DPL WHC.)

JOSHUA MONTI GATEWAY. Given to Denver by Joshua and Victoria Monti in 1916, this gate allows access from the eastern side of the park via Montview and Colorado Boulevards. Shown here under construction, the gateway was the visual and practical doorway for the rising complex of the Colorado Museum of Natural History. Colorado Boulevard, a mere dirt road at this time, would later become the busiest street in the entire state. (DMNS.)

JOSHUA MONTI. A prominent pioneer miner, rancher, and Georgetown businessman, Monti also has the distinction of being the neighbor of Molly Brown. When she and her husband, J. J. Brown, moved to Denver from Leadville in 1894, the Monti family was already residing next door at 1344 Pennsylvania Street. After their 1886 mansion was destroyed in the 1960s, fears that the Brown home was next pushed citizens to organize Historic Denver. (DPL WHC.)

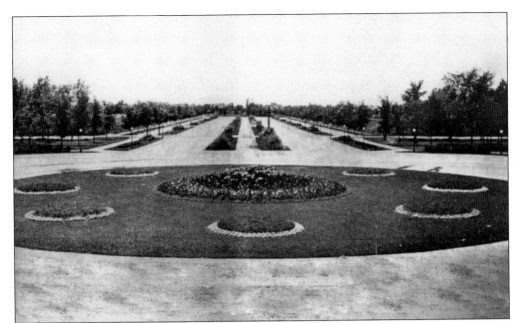

ESPLANADE ENTRANCE TO CITY PARK, 1910. This was the view along the Esplanade prior to the erection of the Dennis Sullivan Gateway in 1917. Today the Esplanade still stretches from Colfax Avenue to City Park, two blocks to the north. The original intention was for Denver's major parks to be linked by miniature linear parks like this. Although never completely realized, Denver does contain a few similar stretches of park elsewhere. (DMF.)

DENNIS SULLIVAN. Sullivan worked as a director with Joseph A. Thatcher at the Denver National Bank. Upon his death, $35,000 was donated to the city in order to build the Sullivan Gateway. Flanking each side of the Esplanade would be two 40-foot pylons with statues atop, part of an imposing gateway that had a width of 570 feet. Of all the gateways into City Park, Sullivan's was the most lavish. (DPL WHC.)

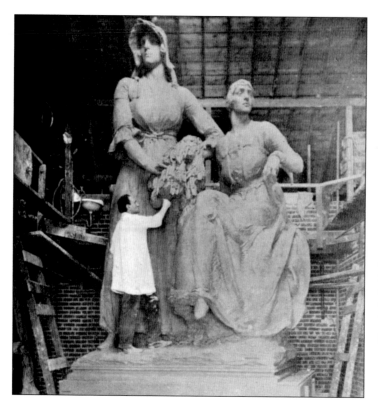

A TERRA COTTA MASTERPIECE. This photograph, taken in 1918, shows sculptor Leo Lentelli working on *Agriculture*, a sculpture depicting two women gleaning wheat during the harvest. Along with a statue of *Mining*, the two 14-foot-tall monuments grace the Sullivan Gateway into City Park. A trash dump in 1900, the land was donated by the state for improvement. The elaborate floral displays were later replaced by this monumental gateway. (DMF.)

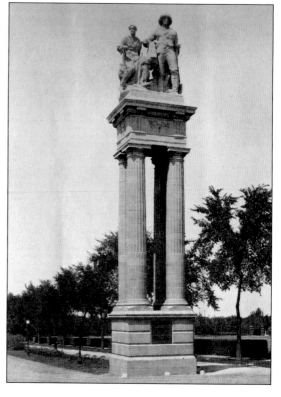

THESE STATUES MAY NOT LAST. Two miners stare into the distance on the pylon that complements the adjacent agricultural theme. Leo Lentelli originally planned something a bit different, "*Mining* will be represented by a pioneer prospector examining a piece of ore, while the inevitable burro waits patiently for the next move." The two statues, made of erosive materials, did not fare well during the 20th century but luckily received extensive restoration work during the 1990s. (DMF.)

THE GRANDEUR OF THE SULLIVAN GATEWAY, 1918.
The information for the picture expresses the heroic
stature of the gateway in this caption from the October
1918 *Denver Municipal Facts*, "Few monumental
gateways in the country have the magnificent
proportions of this, which is unique also in the fact
that it was constructed of terra cotta. The graceful
proportions of the side walls, surmounted by urns,
show the possibilities in this construction." (DMF.)

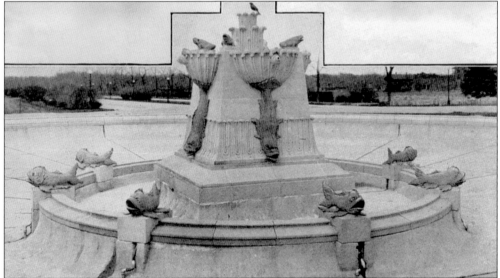

THE DOLPHIN FOUNTAIN. This fountain was installed as part of the overall plan for the Sullivan
Gateway. The whole gateway was funded by friend John C. Mitchell as well as the Denver National
Bank. The fountain was part of the array of visually stunning amenities that made up the Sullivan
Gate. The *Denver Municipal Facts* explained in 1918, "In the center is a handsome fountain, jets
being spouted from the mouths of dolphins and frogs." (DMF.)

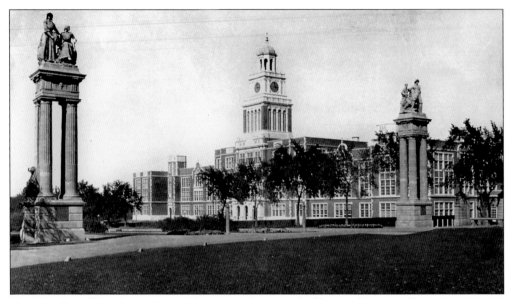

THE NEW EAST HIGH SCHOOL, 1925. Leaving its longtime building in downtown Denver, prestigious East High School was relocated to land next to City Park. Jacobean in style and designed by architect George Williamson, the building is excellently framed by the Sullivan Gateway along the Esplanade. One of the most breathtaking of any of Denver's high schools, the building still turns heads after all this time. City Park remains an amenity for students. (KJC.)

THE DOMAIN OF EAST ANGELS. Typically the rival high school for Manual Training High School, which is close by, East High School's beauty is apparent both inside and out. Through the main doors, which face toward the mountains to the west, light pours in to illuminate the lobby and main stairwell of the school. Descended from the first public high school held at the old Arapahoe School downtown, East High School has been graduating students since 1877. (DMF.)

THE CHILDREN'S FOUNTAIN, 1912. The City Beautiful efforts included many offerings for kids. Mayor Robert Speer was inspired by one of his European trips and had this replica of a fountain he found in Dusseldorf placed in City Park. *Denver Municipal Facts* stated that the fountain "has had an important influence upon the acquisition of later works of art." The park held many hidden corners where such treasures could be found. (DMF.)

SEACOAST MORTAR. Donated in 1897 by the Grand Army of the Republic, this seacoast mortar was one of three Civil War artillery pieces given to Denver. The guns remain in City Park and are among the oldest objects still extant in the park. They represented a growing sense of American strength. The Spanish-American War a year later would create a tsunami of patriotic vigor. (Carl Maul Family Collection.)

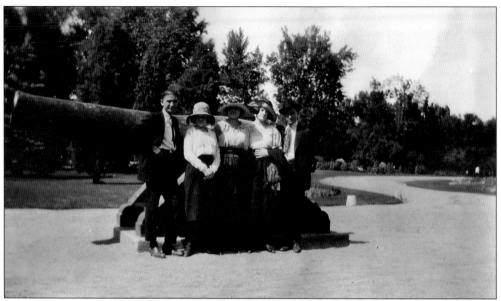

Navy Dahlgren, or Columbia Gun. This piece of 11-inch Civil War artillery was originally on the USS *Canadaigua*. It was used for coastal defense. It has had a number of smaller bodies of water in its sights, including Duck Lake, during its time within the park. From left to right, Dario Carletti, an unidentified friend, Katherine Carletti, Lucille Ferarro, and Charles Carletti pause to admire the gun. (Nicolette Dreith Rounds.)

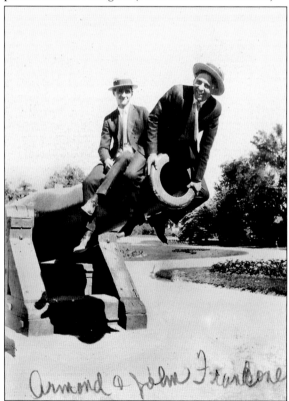

Plaything and Photospot. Though placed within the park in a desire to honor veterans, the cannons appear in innumerable pictures throughout the park's history, including here with Armond (back) and John Francone. Visitors have enjoyed it both reverently and acrobatically, thus demonstrating that the freedom those veterans fought for is still being enjoyed today: the freedom to be as silly as one pleases, whenever he or she pleases. (Nicolette Dreith Rounds.)

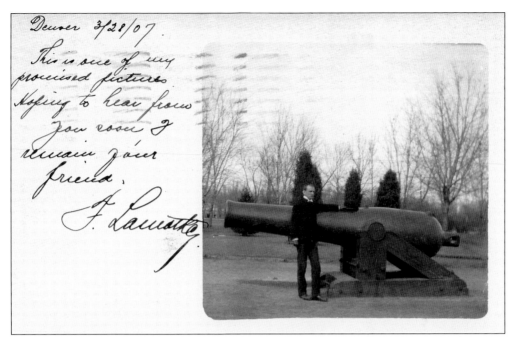

THE PROMISED POSTCARD, MARCH 28, 1907. This real-photo postcard carries a personal message from the hat-doffed gentleman to one back home, "This is one of my promised pictures. Hoping to hear from you soon. I remain your friend." The postcard went to Emily Moeller of Rock Island, Illinois. (KJC.)

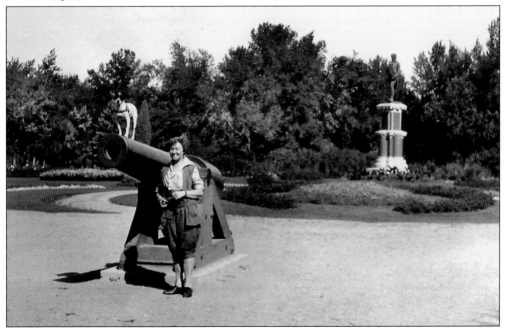

NAVY PARROTT RIFLE, 1929. The third Civil War gun at City Park was also the largest gun of its type. Often visited by pigeons, this cannon offered a vantage point for at least one canine with aspirations in the sky. With the statue of Robert Burns in the background, City Park's most popular picture spot was even suitable for this woman's best friend. (KJC.)

GRACE SMALL MOVES TO DENVER. In the summer of 1917, Grace Small left Missouri for Colorado because of problems with hay fever. Like so many people before her, Small was drawn to Denver for its touted healthful and sunny climate. One of her first jobs was at the Denver Drygoods Company. A visit to City Park was a must-do activity, and a picture with the Navy Parrott documented her trip. (Author's collection.)

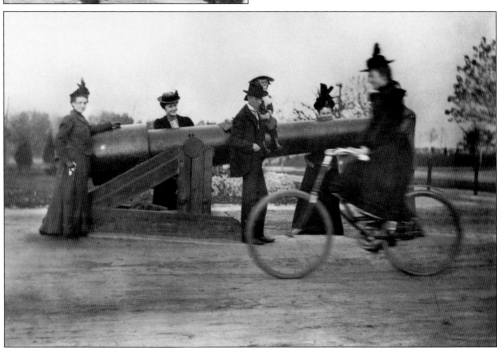

PICTURE INTERRUPTED, C. 1904. There are some dangers in locating one of the park's most beloved picture spots along a busy thoroughfare. Young Katherine Hildebrand is sitting on the cannon behind the gentleman in the hat. Underscoring the commonality of bicycles during this era, a friend rides into the picture, creating a blurry streak. Was it planned? This family has left numerous photographs for posterity but no explanation. (DMNS.)

SPANISH-AMERICAN WAR MONUMENT, 1899. Following the country's rousing victory in the Spanish-American War the year before, boisterous gardeners and landscape architects transformed the artillery-encircled area west of the pavilion into a celebration. The central figure was the statue of an angel, and floral displays surrounded it, taking the shapes of various patriotic and military emblems, such as an anchor. (Carl Maul Family Collection.)

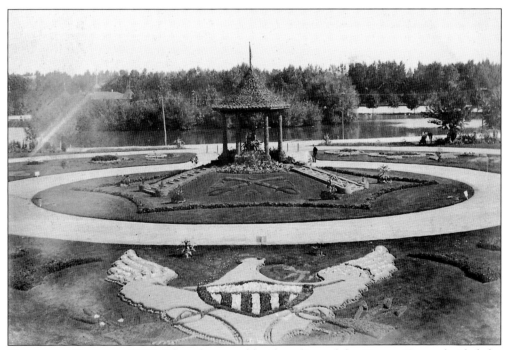

VICTORY IN FLOWERS, 1899. Though some, like the editor of the *Denver Times*, derided the display, Denver's ebullience knew no bounds as it celebrated national success in this four-month war. Most likely designed by Reinhard Schuetze, a red, white, and blue shield-bearing eagle is in the foreground with crossed swords behind. Duck Lake is visible in the background. (Carl Maul Family Collection.)

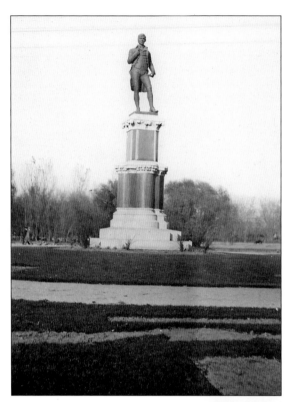

ROBERT BURNS STATUE, 1914. One of Scotland's most beloved sons, this statue was a gift from Edinburgh artist Grant Stevens to the Scots Caledonian Club of Colorado in 1904. Engraved into the stone at the bottom of the statue are the words, "A poet, peasant born / Who more of fame's immortal dower / Unto his country brings / Than all her kings." The statue was placed on the site of the Spanish-American War monument. (KJC.)

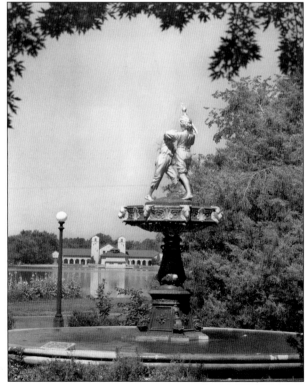

THE MYSTERY OF THE MISSING FOUNTAIN. The Peppard Fountain was erected around 1920 in "Memoriam of John and Minnie Peppard and Their Children." The fountain graced the east side of the lake, but its fate after about 1950 is unknown as it no longer remains in City Park. The Peppards' children died at a young age. Their will left about $3,000 to be spent on the cast-iron fountain, which shows two frolicking boys. (DPL WHC.)

DARIO CARLETTI AND MILDRED. Sitting on a ledge surrounding the Peppard Fountain, Dario Carletti is perhaps enjoying the company of his date. Lover's Lane was popular with visitors to the park, particularly with the young. It followed a meandering line from the Twenty-third Avenue entrance to the pavilion. Perhaps to control any objectionable handholding, the park was sometimes closed at twilight in its early history. (Nicolette Dreith Rounds.)

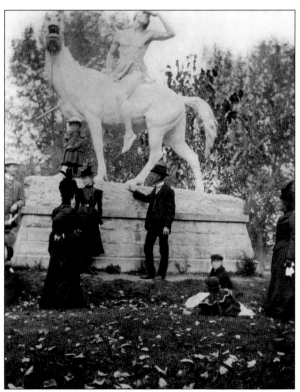

KATHERINE HILDEBRAND STANDING ON THE *INDIAN SCOUT*. Sculpted by Alexander Phimister Proctor during the 1893 World's Columbian Exposition, this sculpture, along with one of a cowboy, made their way to City Park by 1894. The sculptures were made of plaster, and they soon eroded. Proctor eventually made new bronze statues of a similar nature, but they were installed in Civic Center Park instead. (DMNS.)

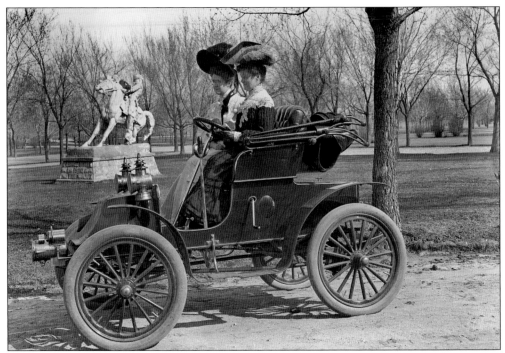

WOMEN DRIVERS, C. 1905. While some of the daring goggle-wearing men of Denver were testing the limits of the horseless carriage at the nearby racetrack, these women took a more placid drive through City Park. Large hats, in keeping with the fashion of the day, also kept the women's hairdos from suffering in the wind. Alexander Proctor's statue, the *Buckaroo*, shows the sheen of plaster in the background. (DPL WHC, X-27311.)

SUPERINTENDENT OF PARK'S HOME, 1893. This lovely home remains within City Park at 2080 York Street. Alexander J. Graham resided in the house starting in 1893, fulfilling his position as park superintendent but also paying rent to the city. Known today as the Graham-Bible House, it also honors James A. Bible, a park employee for more than 50 years. Between 1952 and 1970, he also resided in this home. (KJC.)

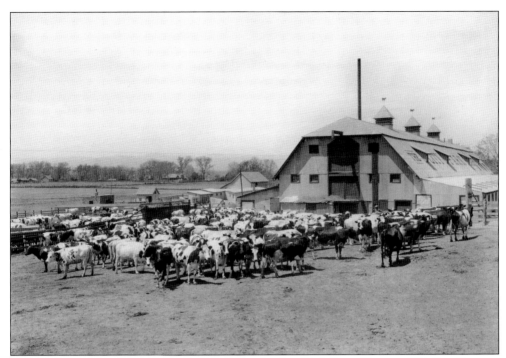

CITY PARK DAIRY. The 1909 *City Directory* lists the City Park Dairy Farm at 3301 East Twenty-third Avenue, directly north of the park. Not surprisingly, agricultural uses near the park were quite common. Hay and oat farmers leased areas of undeveloped land. Park teamsters also resided on this land, where they could maintain some of the teams of horses that worked in the park. (DPL WHC, MCC-3935.)

CREAMED COTTAGE CHEESE. The large dairy was a well-known Denver institution. At the beginning of 20th century, Colorado was one of the most productive dairy states. As the city grew, however, common complaints over agricultural smells and cows being located next to residences began to grow. The city was meeting the country. Relocating to southeast Denver after 1920, the land eventually became the City Park Golf Course. (KJC.)

THE DENVER ZOO AT CITY PARK. What started with a single bear in 1896 progressed to bison, elk, and deer—all contributing to Denver's zoo. Victor Borcherdt, a designer and builder of more realistic environments, is shown working on one of his creations. Bear Mountain opened in 1918 and immediately set the Denver Zoo apart from other zoos. The habitat was the first in the nation to mimic the animal's natural environment. (DMF.)

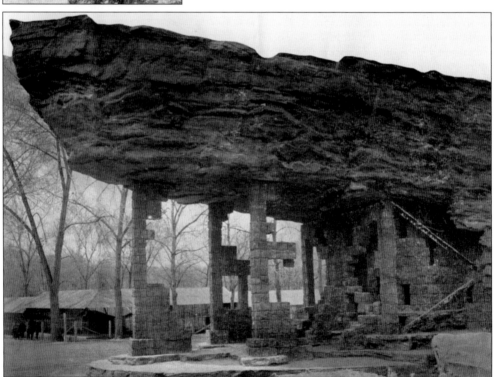

THE FIRST MONKEY ISLAND, 1919. "Beneath a great, overhanging rock in the Habitat Zoo in Denver's City Park is a replica of a Mesa Verde cliff dwelling, and the monkeys who live within add a quaint touch of Darwinism to the scene," reads the caption of this photograph in the May 1919 *Denver Municipal Facts*. Keeping with the city's ambition, crude cages (left) were replaced by more authentic habitats. Due to monkey escapes, this southern extension of Bear Mountain eventually became home to seals. (DMF.)

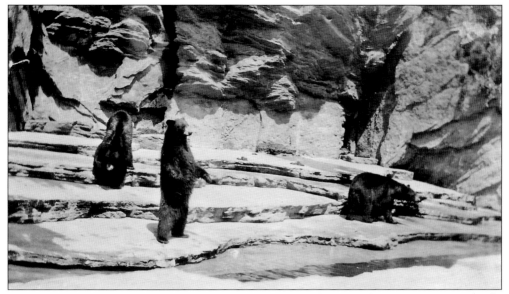

"A GOOD FAT BEAR." Mayor Thomas S. McMurray received a bear cub in 1896, naming it Billy Bryan after presidential candidate William Jennings Bryan. Too rambunctious to remain in the mayor's home, the bear proved too much for a farmer in the park as well; the man's chickens were a favorite for the bear. A more suitable home was built and playmates acquired. By 1919, Bear Mountain was thrilling bears and visitors alike. (DMF.)

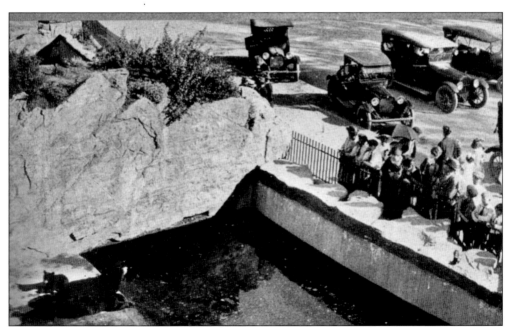

BEARS AND MONKEYS. For much of the zoo's early history, access was as simple as walking to City Park. There were no fences or gates separating the park from the zoo. Later cars could drive right up to Bear Mountain. As seen in the photograph, visitors to Denver in 1920 could look across a simple and safe expanse of water at some of the amusing antics of the bear cubs at the zoo. (DMF.)

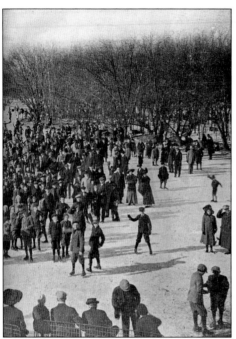

THE LAKE USED TO FREEZE IN WINTER.
Denver's abundant sunshine ensured that folks went outside all year, no matter the temperature. When the lakes in City Park froze, the boats were put away, and skates were strapped on. "Over 6,000 Participated in the Day and Evening Ice Festivities. At Night There Was Skating by Electric Light," stated the *Denver Municipal Facts*. (DMF.)

THE DAUGHTERS OF COLORADO. Formed in 1910, this group was composed of women who could prove their ancestors arrived before statehood. This photograph shows the Daughters celebrating the anniversary of statehood on August 1. They sought to preserve the history and traditions of those early Western pioneers. Denver celebrated the anniversary of statehood with gusto, and City Park was the center of the city's festivities. (DMF.)

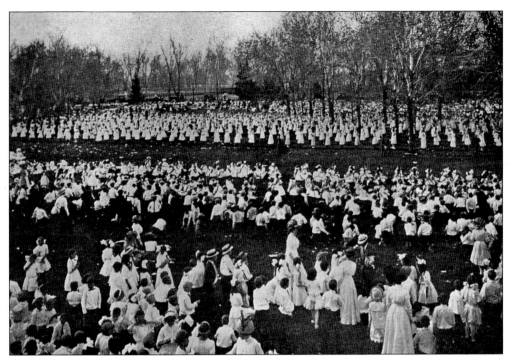

MAY DAY CELEBRATION, 1912. Restrained and well choreographed, 38 Denver schools strut their stuff in displays both large and small. This photograph shows a precision gymnastic drill for the girls, some of the more than 2,000 children who participated. Highlights of the day included attendance surpassing 80,000, twenty-four children lost then safely found, and a hospital tent that was practically useless, owing to the safety and civility of the day. (DMF.)

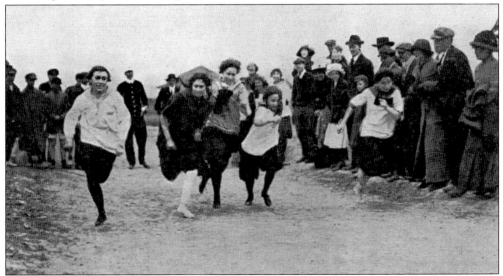

GIRLS' TRACK MEET, 1912. Bloomers and button-up shoes did not slow the girls from Manual Training High School. Competing in the first track meet of the 1912 season, the identity of the winner of this race has been lost, but the image clearly communicates their enthusiasm. Many races, such as this one, took place in City Park, where there was more room for children from multiple schools to gather. (DMF.)

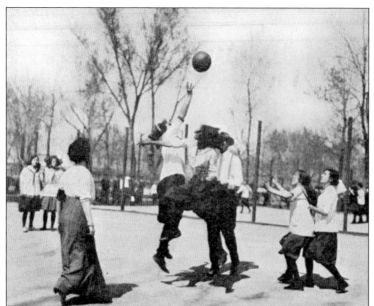

WHEN GIRLS WERE EXPECTED TO PLAY. "Putting the Ball in Play at the Cheltenham-Whittier School Basket Ball Game," described this edition of the *Denver Municipal Facts* in 1912. Some of these girls may have gone on to fame as a Thunderbolt at Manual Training High School or a Cowboy at West High School, near Denver's Cheltenham School. (DMF.)

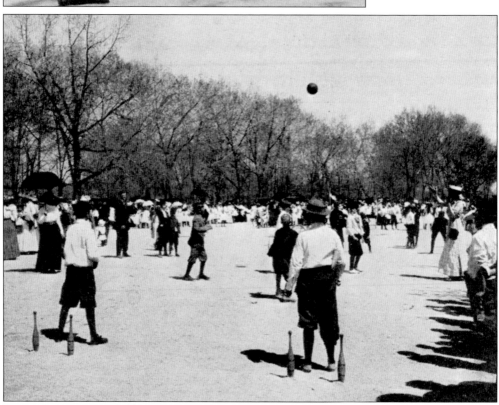

BATTLE BALL, 1912. Children are engaged in a game of battle ball, competing for the championship at the Play Festival held in City Park that year. As always, adults were present to enjoy the game and keep order. The two children in the foreground stand next to a set of Indian clubs. Especially popular during the late 19th century, they were used for aerobic exercise and weight training. (DMF.)

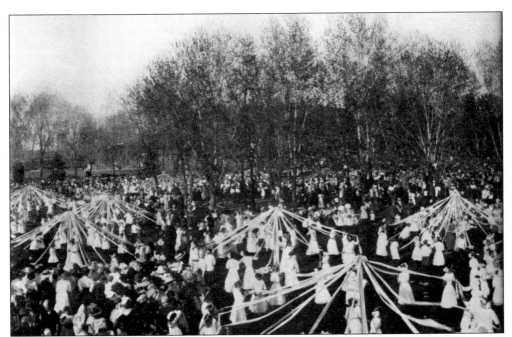

THE MAYPOLE TRADITION, NOW LOST. *Denver Municipal Facts*, with a strong penchant for capital letters, related the following in one of its May 1912 editions, "Panoramic View of the May Pole Dance at Denver's Second Great Play Carnival Showing Nineteen Sets of Dancers and as many May Poles and the Throng of Proud Parents Surrounding the Field." (DMF.)

A NEW FLAG BY ANDREW CARLISLE CARSON, 1911. Colorado Day, celebrating the state's August 1 birthday, was a serious affair, much of which took place at City Park. *Denver Municipal Facts* shared this winsome description of one of these gatherings, "It was a day of reunions of all the old Colorado pioneers. Flapjacks were cooked over a buffalo-chip fire and prizes were given for the biggest 'lie' and the best true story." (KJC.)

113

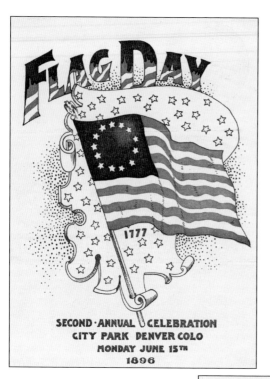

SECOND · ANNUAL ⏜ CELEBRATION
CITY PARK DENVER COLO
MONDAY JUNE 15TH
1896

FLAG DAY ARRIVES EARLY IN DENVER. While U.S. president Woodrow Wilson made Flag Day official in 1916, Denverites had already been making the honoring of the nation's flag a grand event, as evidenced by this program from 1896. Patriotic holidays were celebrated with more fervor in the late 19th century; with many advances in workers' rights still in the future, some American workers got only the holidays of Independence Day and Christmas off from work. (KJC.)

AN INCLUSIVE PROGRAM, 1896. Denver's Flag Day celebration for 1896 indicates that great care was taken to ensure that all members of the community were included. Well-known Coloradoans such as Ralph Voorhees, as well as the governor and mayor, took part in the festivities. But interestingly, Rabbi William Friedman from Temple Emmanuel also gave an address, as did the Reverend E. W. Moore from Zion Baptist Church. (KJC.)

…◦◦◦PROGRAMME…◦◦◦

INTRODUCTORY .. RALPH VOORHEES
President Society Sons of the Revolution.

PRAYER .. REV. R. V. L. MOFFETT, PH. D.
Chaplain Society Sons of the Revolution.

ADDRESS .. HON. A. W. McINTIRE
Governor State of Colorado.

ADDRESS .. REV. E. W. MOORE
Pastor Zion Baptist Church, Colored.

ADDRESS .. WM. S. FRIEDMAN
Rabbi Temple Emanuel.

SONG "Onward Christian Soldiers" BY THE ASSEMBLY

ADDRESS .. REV. WILLIAM O'RYAN
Pastor St. Leo's Church

ADDRESS .. HON. T. S. McMURRAY
Mayor of Denver.

ADDRESS .. REV. JAS. D. RANKIN
Pastor First United Presbyterian Church.

SONG "America" BY THE ASSEMBLY

SALUTE TO THE ORIGINAL FLAG, THIRTEEN GUNS CHAFFEE LIGHT ARTILLERY

WHEN THE DERBY WAS COMMON. A century ago, the derby was a ubiquitous fashion for many men in the United States, Denver included. After the 1850s, it became much more common as the popularity of the top hat faded. In this photograph from 1900, a man peers into the camera as a group of boys stands next to a water fountain at City Park. (GKC.)

INDIAN CAMP, 1900. Though visited by Ute, Sioux, and Navajo, this former elk pasture was known simply as the "Indian Camp." Complete with teepees, papooses, and ululating dances, the temporary encampments drew large crowds. Visitors paid an admission fee for the chance to view the "authentic" camp and buy blankets, pottery, and other handcrafted items made by the residents. Picture taking was also a must. (GKC.)

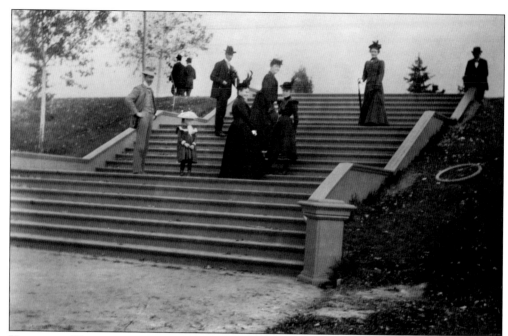

KATHERINE HILDEBRAND ON THE STEPS, C. 1904. This family, complete with young Katherine, poses for a picture. One of the ladies has left her bicycle on the grass on the right side of the picture. It is the same bicycle seen in the picture of this family on page 102. A trip to the milliner was a common pastime for these women, as was a trip to the haberdasher for the men. (DMNS.)

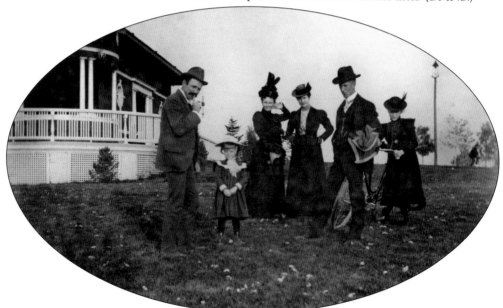

KATHERINE HILDEBRAND SMILES NEAR THE PAVILION, C. 1904. The continuing improvements to City Park would continue all during Mayor Robert Speer's time in office. Said Speer, "From history we learn that the cities which have outlived all others, are those which have in some form or other cultivated art and beauty. Beauty in a city is an asset, with more drawing power than is generally recognized." (DMNS.)

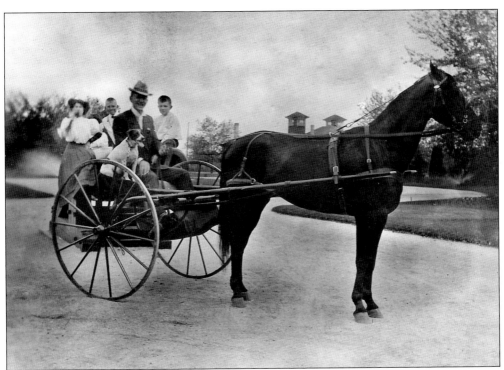

A Horse and Cart, c. 1908. This family enjoys a pleasant ride through City Park. For visitors who did not bring their own horse and buggy to the park, one could be rented for a small sum. In this picture, the pavilion can be seen in the distance. Even the family dog is along for the ride. (KJC.)

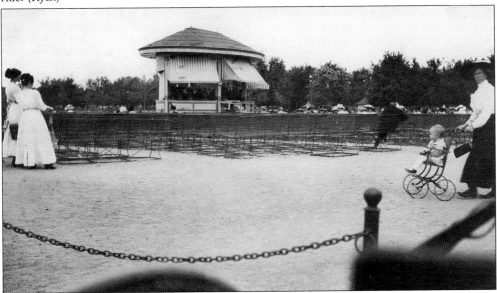

"My Buggy," August 23, 1911. On this real-photo postcard, Jack wrote, "Spending an afternoon at the park in Denver. The shadow at bottom is my buggy." Sent to G. A. Lindsten in Huron, South Dakota, Jack neglected to identify the structure as the floating bandstand or that the seats were most likely set up for a concert. Perhaps Jack was merely passing through. (KJC.)

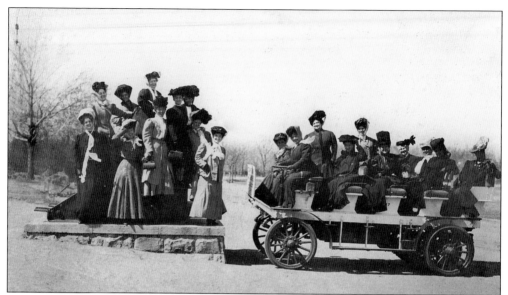

"EVERYBODY'S HAPPY" ON THE CANNON OR IN THE CAR. This photograph is dated March 26, 1907. Automobile tours were increasingly popular during the early 20th century. This photograph includes all the names of the ladies enjoying the outing. Some of the names are illustrative of the popular choices of the day, including Agnes, Nellie, Edith, Millie, Stella, and Gertrude. (KJC.)

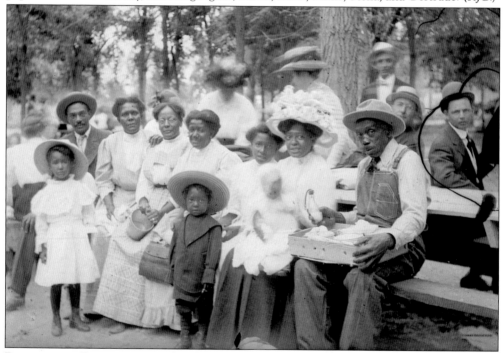

PICNIC IN THE PARK, C. 1909. This photograph, taken about the year the National Association for the Advancement of Colored People (NAACP) was founded, shows a family enjoying the amenities of City Park. Such outings were an occasion requiring one's best clothes, no matter what age. Since there were no restaurants in the park, summer saw entrepreneurs crisscrossing the park, just in case any picnickers had forgotten something. (CHS No. 20002084.)

WALNUTS, SEPTEMBER 10, 1909. "Dear Aunt Nellie. This was taken out at City Park, September 2nd. I had quite a time to get the squirrel to sit there. He has his mouth full of English walnuts." Feeding the beasts of all sizes has long been an attraction at City Park. This gentleman is wearing a boater, a type of straw hat worn during warm weather. It was popular a century ago. (KJC.)

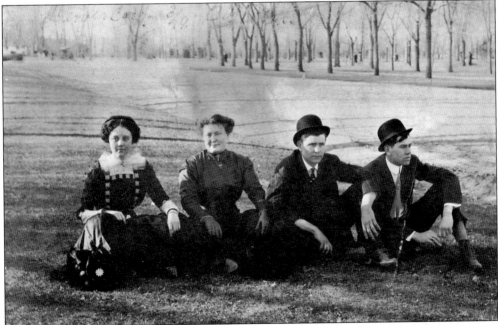

A CHANGING ERA, MARCH 24, 1911. A revolution of sorts would replace walks and bicycle rides with the automobile. Quaint at first, the novelty soon wore off and threatened the very foundations upon which the park was built. Said Bette Peters, "Crowded conditions in the park . . . were aggravated by the Stanley Steamers and the more popular electric cars which were creating new hazards for pedestrians and gentle horse teams." (KJC.)

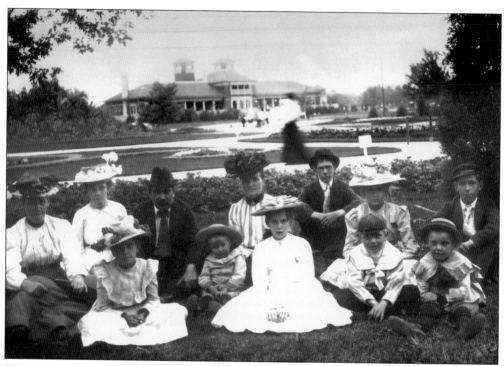

PEACE AND QUIET NEAR THE PAVILION.
With initial land being purchased for City
Park in 1882, great investment by the city
of Denver, as well as prominent citizens, left
a magnificent legacy to the future. While
a small push occurred in 1922 to rename
the park in honor of William McLellan, the
park has remained simply "City Park" to
the present day, but it really is more than
its name. (CHS, Lillybridge Collection.)

A NEW ERA IS DAWNING, LADIES. In what
may very well be an apocryphal story,
Calamity Jane went into a bar and asked for
a drink. "We don't serve ladies." Pulling out
her pistol, she answered back, "Give me my
drink; I ain't no lady." Whether or not she got
her drink, Clara and Edith Francone decided
to emulate her example, donning these men's
boater hats for this photograph. City Park
has seen it all. (Nicolette Dreith Rounds.)

Eight

OUR CURIOUS PATHS

THIS SCHOOL IS OURS

By Thomas Hornsby Ferril, Whittier School
Class of 1910

This school is ours, this Whittier School,
It's your school and it's mine,
It was my school so far ago
The long years intertwine
In memory between the things
That here at school I knew,
And things that happen every day
At school right here with you.

So when I meet you girls and boys
I like to wonder how
You will look back on Whittier School
A long long time from now,
When maybe you'll return like me
And maybe try to say
To other girls and boys the things
We try to say today.

So let's pretend you're very old
And I am just a boy,
And we've come here to talk about
The pleasures we enjoy,
And things that give us trouble
And make us want to quit,
And then how wonderful it feels
To get the best of it!

That's what we're here for, don't you think?
To change our problems into fun
And go home happier at night
Because of what we've done?

For school is like a story-book
That, page by page, we turn
To learn about this world of ours
And, most of all, to learn
About ourselves, so, all of us,
Let's thank our Whittier School
For helping you and me to make
Our lives more beautiful!

Thomas Hornsby Ferril
November 5, 1964

THIS SCHOOL IS OURS,
NOVEMBER 5, 1964. Residing
at 2123 Downing Street,
Thomas Hornsby Ferril was
Colorado's poet laureate from
1979 to 1988. He often wrote
about the pain of seeing
Denver's past erased from
history. Reading this poem at
the dedication of a modern
wing of Whittier School,
he was also witness to the
destruction of the original
Whittier in 1973. In 1996,
the big lake at City Park was
named in his honor. (WES.)

AN ORIGINAL WHITTIER GATE, TWENTY-FOURTH AVENUE AND DOWNING STREET. Whittier saw many Denver firsts, including the hiring of Marie Greenwood in 1935 as the first black teacher and Jesse Whaley Maxwell. Maxwell served as the first black principal at both the Whittier and Columbine Schools. Both women have schools named for them. In 1998, Maxwell stated, "It is humbling to think of this school dedication. But this is more than mine. It's a symbol of the progress that has been made." (Minka Frohring.)

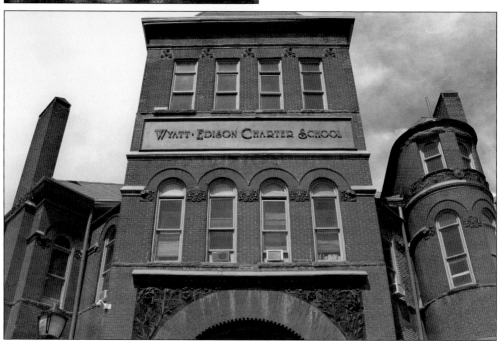

WYATT-EDISON CHARTER SCHOOL, 2009. The former Hyde Park School was renamed to honor principal George Washington Wyatt in 1932. The school closed in 1982 and was abandoned for 15 years. This neglect helped save the structure from demolition, and it was reborn, after extensive renovation, as the Wyatt-Edison Charter School in 1998. The school had opened in January 1889 to 876 students. It stands today as the second-oldest school structure in Denver and serves the neighborhood once again in all its architectural grandeur. (Minka Frohring.)

MANUAL TRAINING HIGH SCHOOL, 1940.
The growing diversity of the Manual student body reflected changing demographics in the area. In 1953, a new building opened. By the late 1950s, black students had become the majority in what continued to be Colorado's most diverse student body. The *Rocky Mountain News* declared in 1956, "Manual High Students Find Melting Pot Setup Is Great." Surviving desegregation from 1974 to 1995 and a brief closure, proud Manual's future remains tenuous. (MHS.)

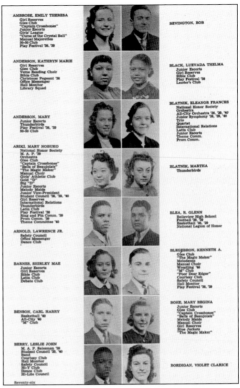

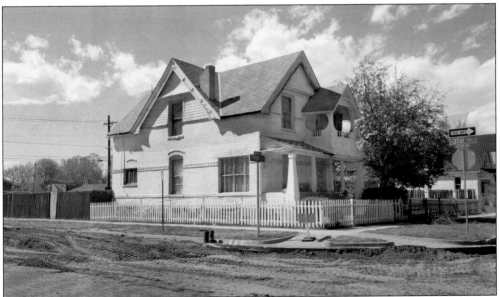

THIRTY-FIRST AVENUE AND HIGH STREET, 2009. This proud 1890 Victorian home still stands, where it was also photographed 100 years earlier (see page 19). Purchased for a mere $8,000 in 1991, the house survived another economic cycle of uncertainty. Since the 1990s, many of Whittier's old homes have been renovated. New interest in city living, along with proximity to downtown and other amenities such as City Park, have made Whittier a prime candidate for gentrification. (Minka Frohring.)

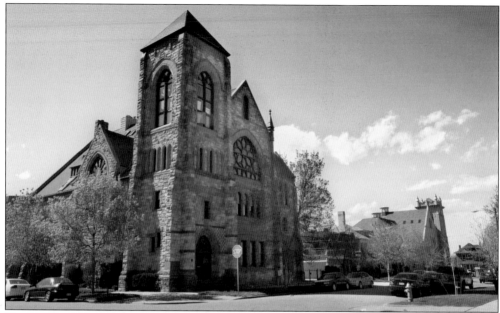

THE SANCTUARY LOFTS, 2009. Scott Methodist Church (see page 37) left the neighborhood in 1969. As housing opportunities continued to open up in newer areas of northeast Denver, black citizens began leaving the Whittier area. The neighborhood's population continued to decline year after year. This abandoned church was converted into lofts in 1995. New Hope (shown at right) left in 1993. The building is currently being converted into lofts as well. (Minka Frohring.)

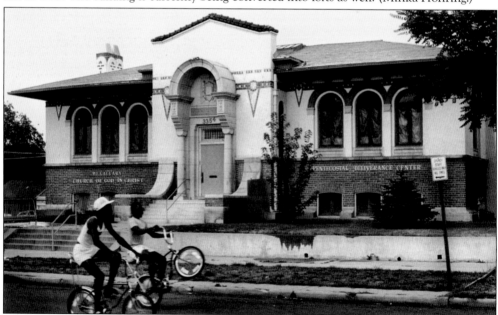

THE OLD WARREN BRANCH LIBRARY, 1986. The stately 1913 building was replaced by the newly built Ford-Warren Library at 2825 High Street in 1975. The new library name also honored Dr. Justina Ford. The old building was converted into a church and later into lofts. Other changes to Whittier occurred in 1980 when East Thirty-second Avenue became Martin Luther King Jr. Boulevard. (Tom Noel.)

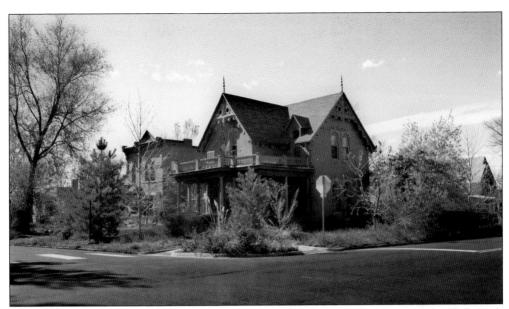

SCHULZ-NEEF HOUSE, 2009. When Gary Kleiner purchased this home (also on pages 52 through 56), he had no idea he was buying a home built in 1881. Property records indicated it was built about 1890. After doing extensive research while preparing an application for landmark designation, he uncovered the rich history of this house. Newscaster Reynelda Muse resided in the home between 1974 and 1987. She was both Colorado's female and first black newscaster. (Minka Frohring.)

A LOVE LETTER FOUND, 1013 EAST TWENTY-SIXTH AVENUE. When homeowner Lynette Prosser began renovating this home in 2002, in the attic she discovered a three-page love letter dated June 4, 1885. Passages include, "And still not so much as a very little whisper from you . . . for it is the first time I have ever been away five days and I feel wretched at not hearing from you. . . . Am I sure of your love . . . I wonder if you miss me." (Lynette Prosser.)

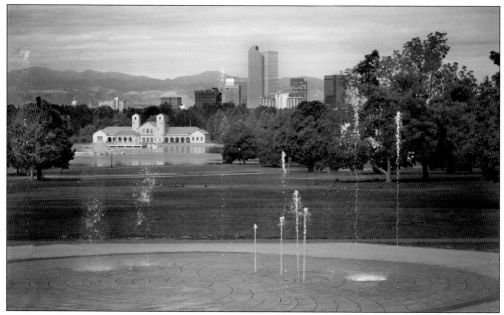

DENVER SKYLINE, 2009. The modern Denver skyline began to take shape during the early 1950s. Today the views from the west steps of the Denver Museum of Nature and Science still allow visitors to marvel at the state capitol, Mount Evans, and the pavilion, but the stunning Denver skyline dominates the show now. The views from City Park Golf Course are even more striking. (Minka Frohring.)

THE MORE THINGS CHANGE. The trees are grown. The guns remain. Each generation has continued to pass on shared memories to the next. Grace Small (see page 102), with an uncharted future ahead, might never have imagined her great-grandson authoring a book about that park and sharing a picture spot with the same cannon. Despite the changes over time, the Whittier neighborhood and City Park still hold quiet places where one may contemplate the past and dream of the future. (Minka Frohring.)

BIBLIOGRAPHY

Brenneman, Bill. *Miracle on Cherry Creek*. Denver: World Press, Inc., 1973.

Denver Municipal Facts. Denver: City and County of Denver, 1909–1931.

Etter, Carolyn and Don. *The Denver Zoo, A Centennial History*. Boulder, CO: Roberts Rinehart Publishers, 1995.

Etter, Don and Carolyn. *Forgotten Dreamer: Reinhard Schuetze, Denver's Landscape Architect*. Denver: The Denver Public Library, 2001.

Fallis, Edwina H. *When Denver and I Were Young*. Denver: Sage Books, 1956.

Fletcher, Ken. *Centennial State Trolleys*. Boulder, CO: Colorado Railroad Historical Foundation, 1995.

Goodstein, Phil. *Denver Streets, Names, Numbers, Locations, Logic*. Denver: New Social Publications, 1994.

Griffith, Stanwood C. "Denver Tramways." *Electric Railroads* 30 (December 1961): 1–20.

Maclin, Gladys M. "Character Education in the Whittier School." *The Journal of the National Education Association* (March 1931): 79–80.

Mauck, Laura M. *Five Points Neighborhood of Denver*. Chicago: Arcadia Publishing, 2001.

Olsen, Margaret Hook. *Patriarch of the Rockies: The Life Story of Joshua Gravett*. Denver: Golden Bell Press, 1960.

Ortin, Carrie E. *A History of Manual Training High School, 1892–1942*. Denver Public Schools Archives. Denver, 1942.

Peters, Bette D. *Denver's City Park*. Boulder, CO: Johnson Publishing, 1986.

Raughton, Jim L. *Whittier Neighborhood and San Rafael Historic District*. Denver: Historic Denver, Inc., 2004.

Schell, Laura. "Saving Buffalo Bill: Discovery of the Jamestown Buffalo Bill Billboard." *Western New York Heritage* (Winter 2009): 32–42.

Simmons, R. Laurie and Thomas H. Simmons. *Whittier Neighborhood*. Denver: Front Range Research Associates, 1995.

Stephens, Ronald J., and La Wanna M. Larson. *African Americans of Denver*. Charleston, SC: Arcadia Publishing, 2008.

Turner, Wallace B. *Centennial History of Calvary Baptist Church, 1881–1981*. Denver: Privately printed, 1980.

www.arcadiapublishing.com

Discover books about the town where you grew up, the cities where your friends and families live, the town where your parents met, or even that retirement spot you've been dreaming about. Our Web site provides history lovers with exclusive deals, advanced notification about new titles, e-mail alerts of author events, and much more.

Find Your Place in History.